love to COLOR

PETALS, PATTERNS AND DOODLES
COLORING PAGES

tiffany lovering

NORTH LIGHT BOOKS
CINCINNATI, OHIO
www.createmixedmedia.com

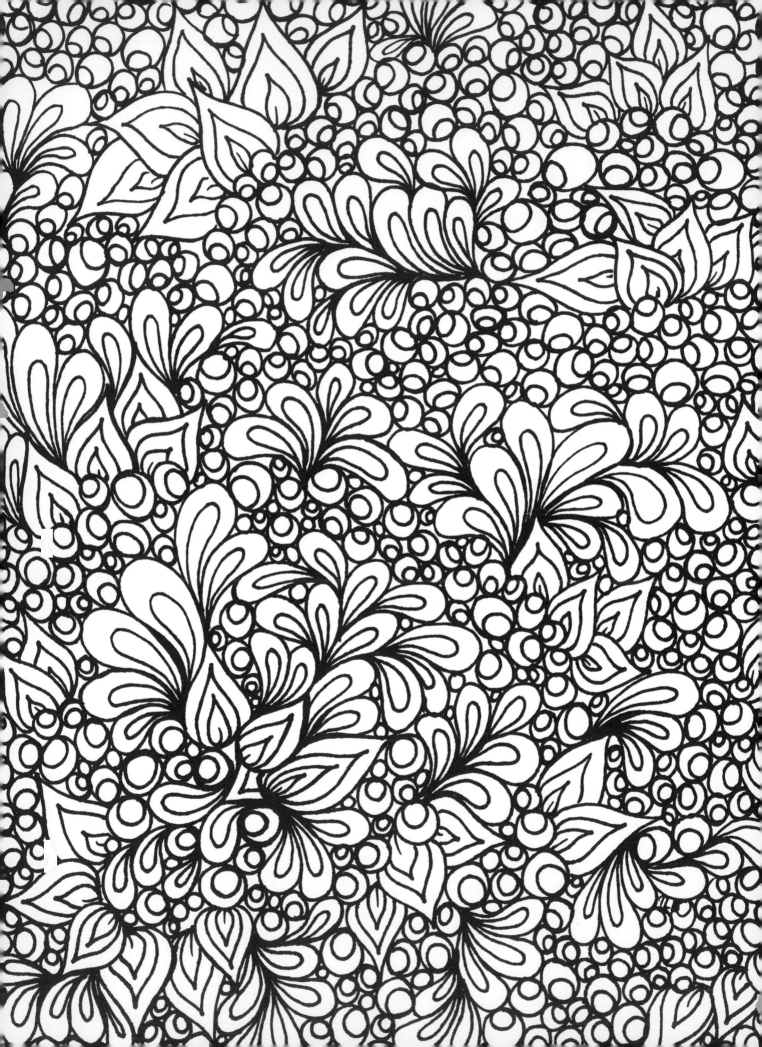

Introduction

When I was a child, there was nothing better than receiving a brand new coloring book and box of crayons.

Coloring was an activity that could easily occupy me for hours without me even realizing it. It was fun to find just the right color for a princess dress or a variety of colors for a magical garden. As I reached my teen years, I would search for more intricate coloring books which were nearly impossible to find in a department store. I eventually realized that I would have to create the coloring pages I was looking for. That's honestly how my love of doodling began. I would spend a week or more after school drawing very intricate pieces and when they were complete, I would hand the pages off to my mother for her to make copies at work for me to color.

When I started my YouTube channel in 2013, I knew that I wanted to eventually create a coloring book. The doodles, mandalas and tangles that I create always look better after shading and coloring is added, in my opinion, and I loved hearing how the people who watched my videos would have colored the pieces I created. As my drawings became larger and more intricate, my daughter, Alli, would ask if she could color them and that's when I knew for sure that I was ready to create a coloring book.

More intricate coloring books have steadily become more popular. It's a stress-reliever, relaxing, mindful meditation and even therapeutic activity that anyone can do. I wish I could claim that it was for these reasons that I created a coloring book as they sound a little more sophisticated than the true reason: Coloring is fun. As much as I love drawing, it's no secret that my favorite part of the drawing process is adding shading and coloring. It's what adds life to the pages.

Each of these pages took anywhere from two to five hours for me to draw and can provide many more hours of coloring for you to enjoy. Use your favorite colored pencils, markers or even some crayons to bring these pages to life with color. I encourage you to try different shading and coloring techniques within this book and have fun while making these pages beautiful.

I hope you will share your finished pages on the Facebook page Love to Color. I will be sharing my own colored pieces on this page as well as providing the occasional free coloring pages for you to print!

Happy coloring!

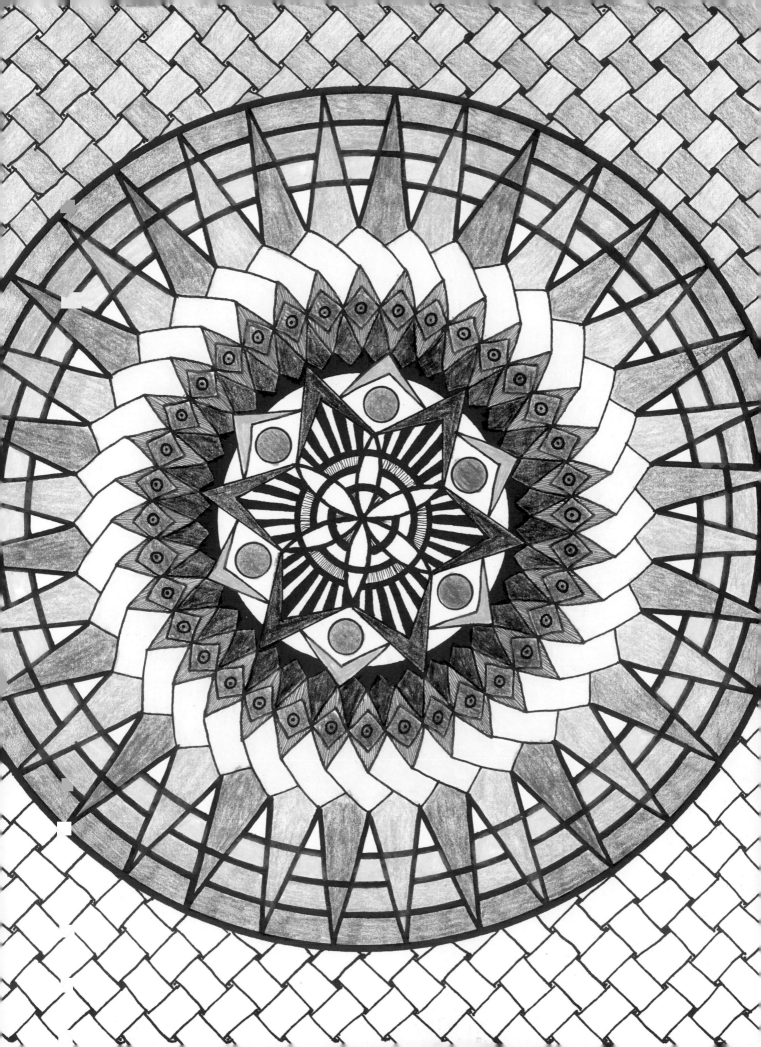

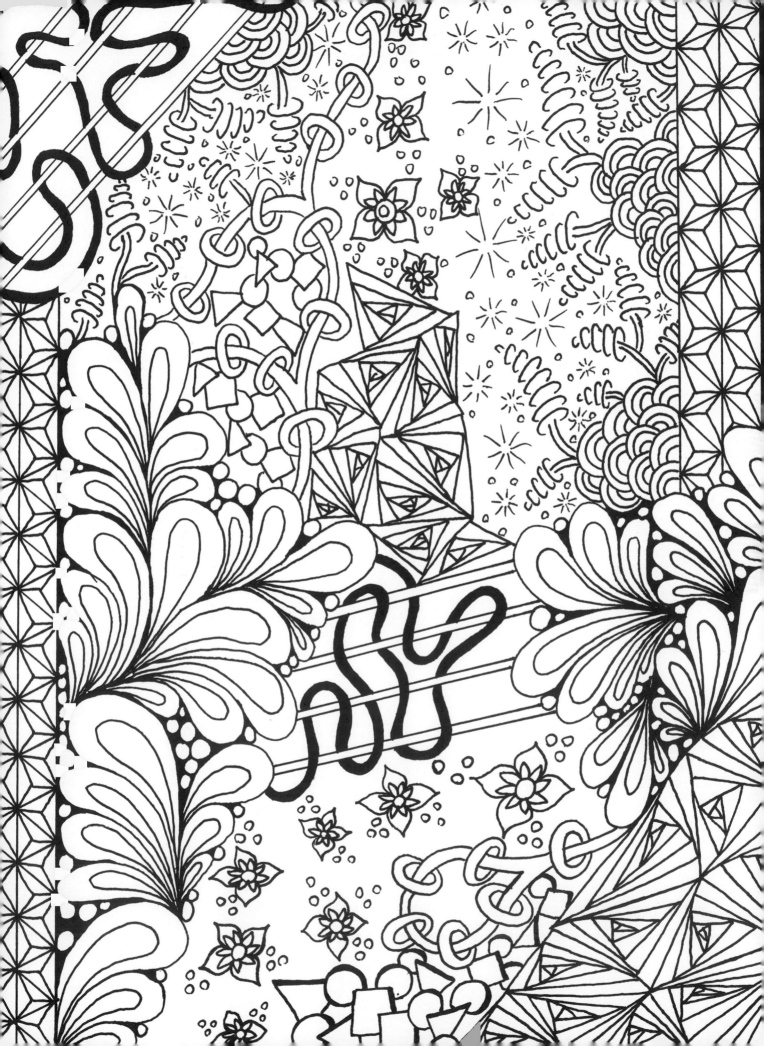

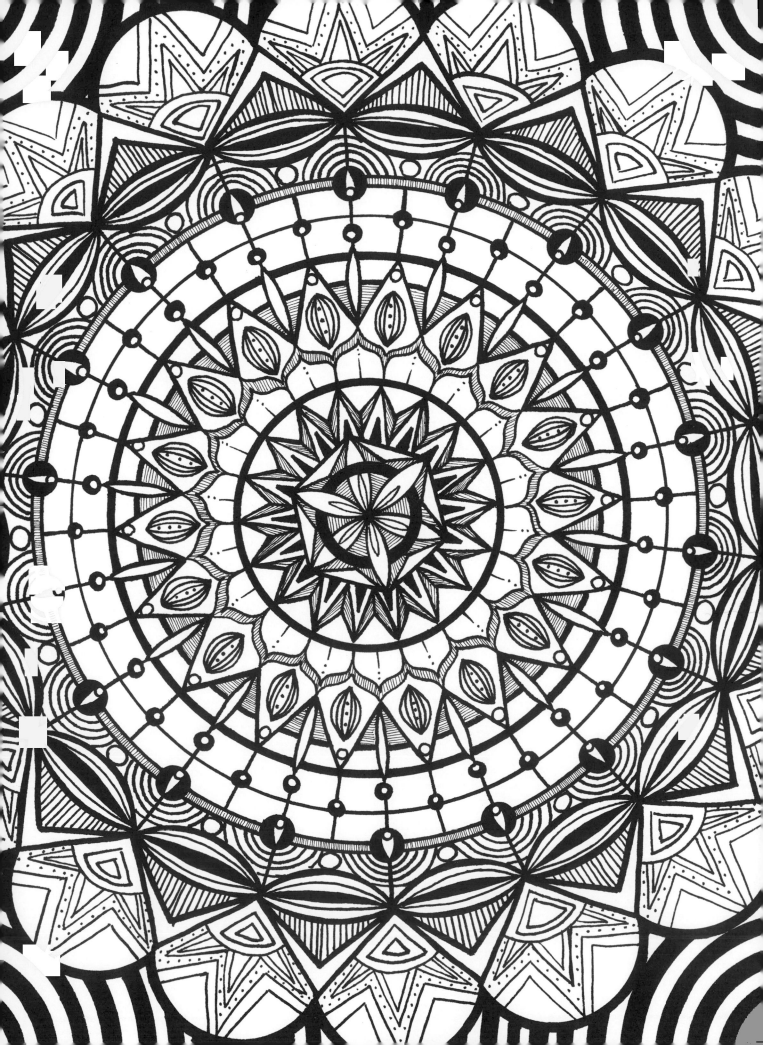

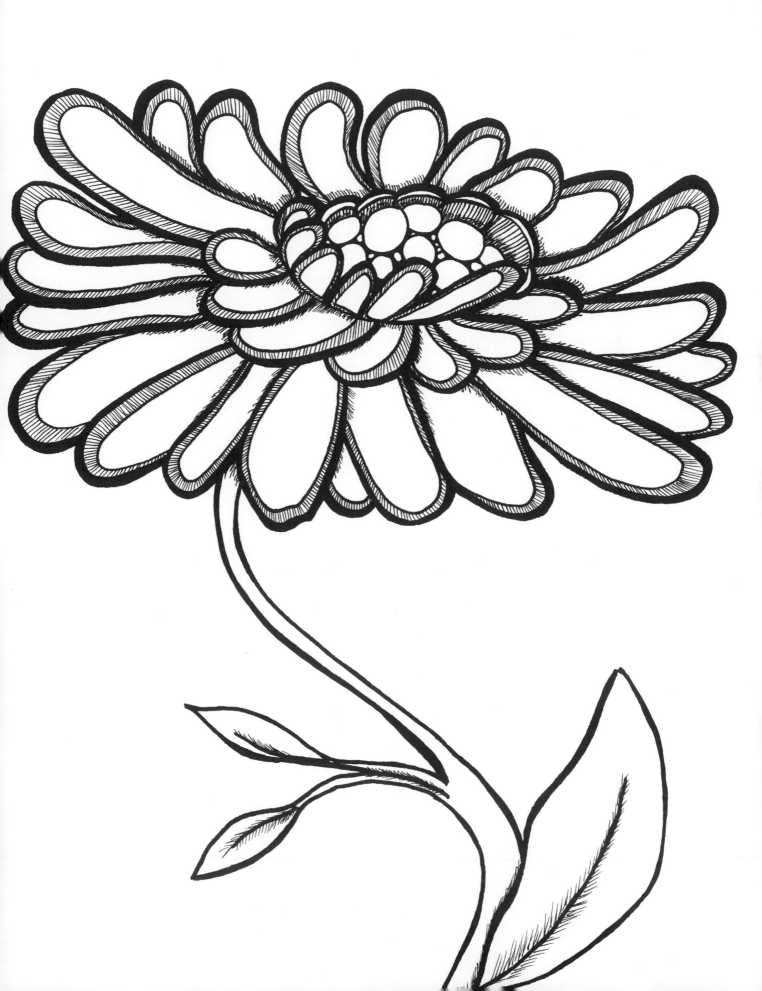

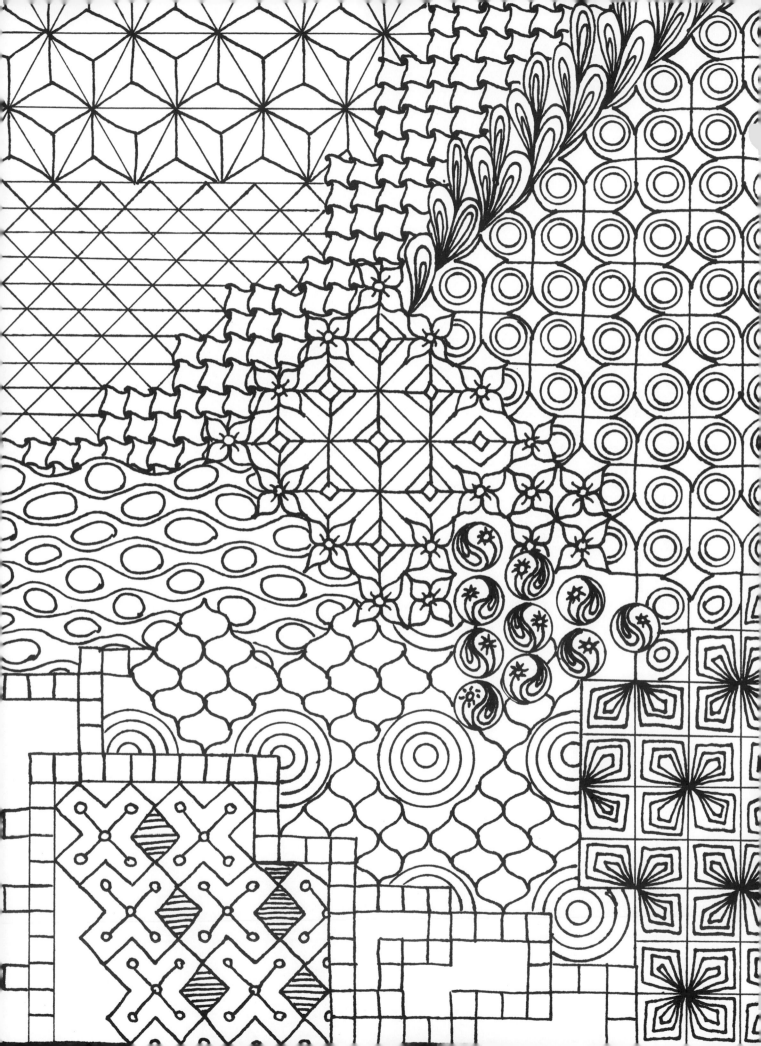

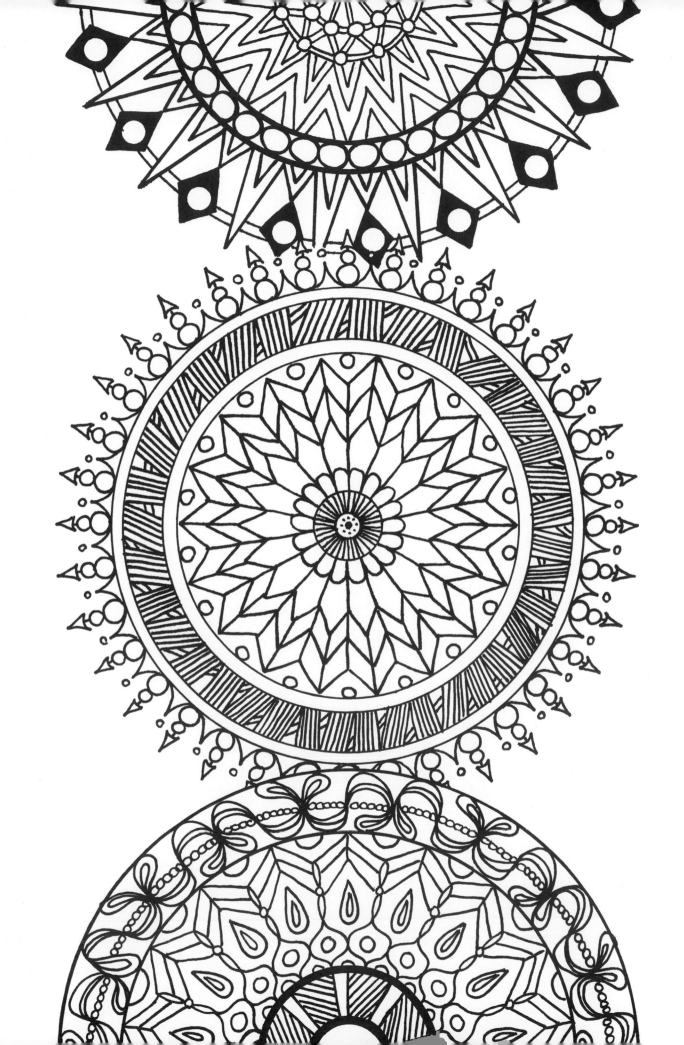

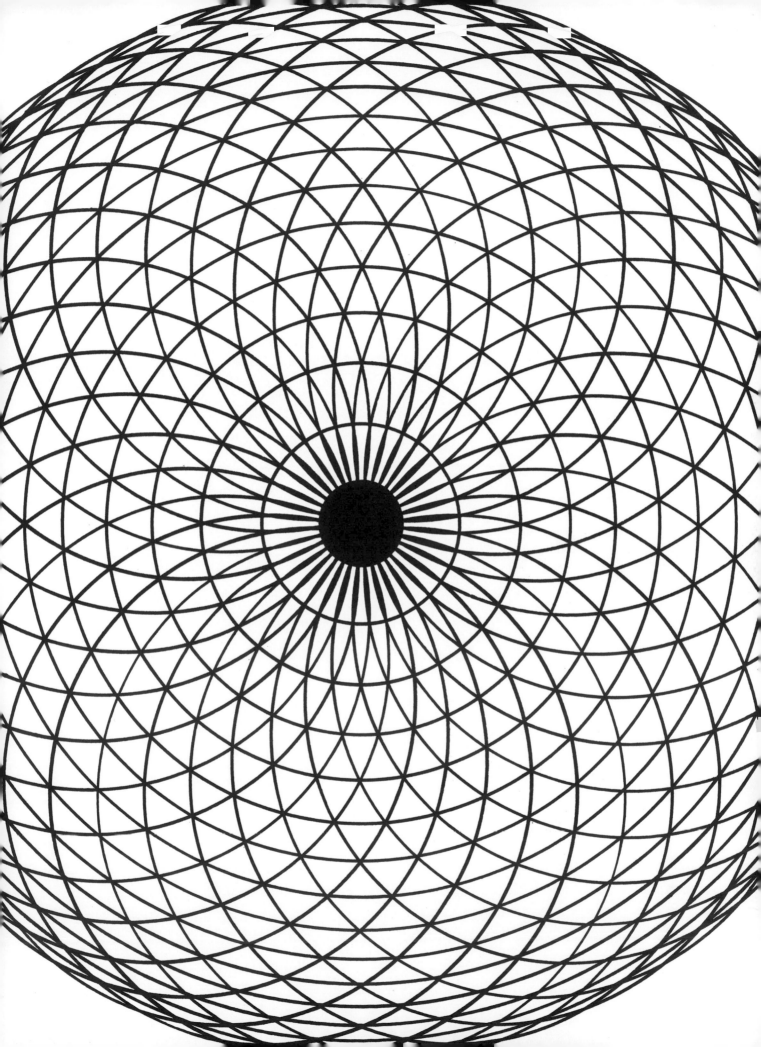

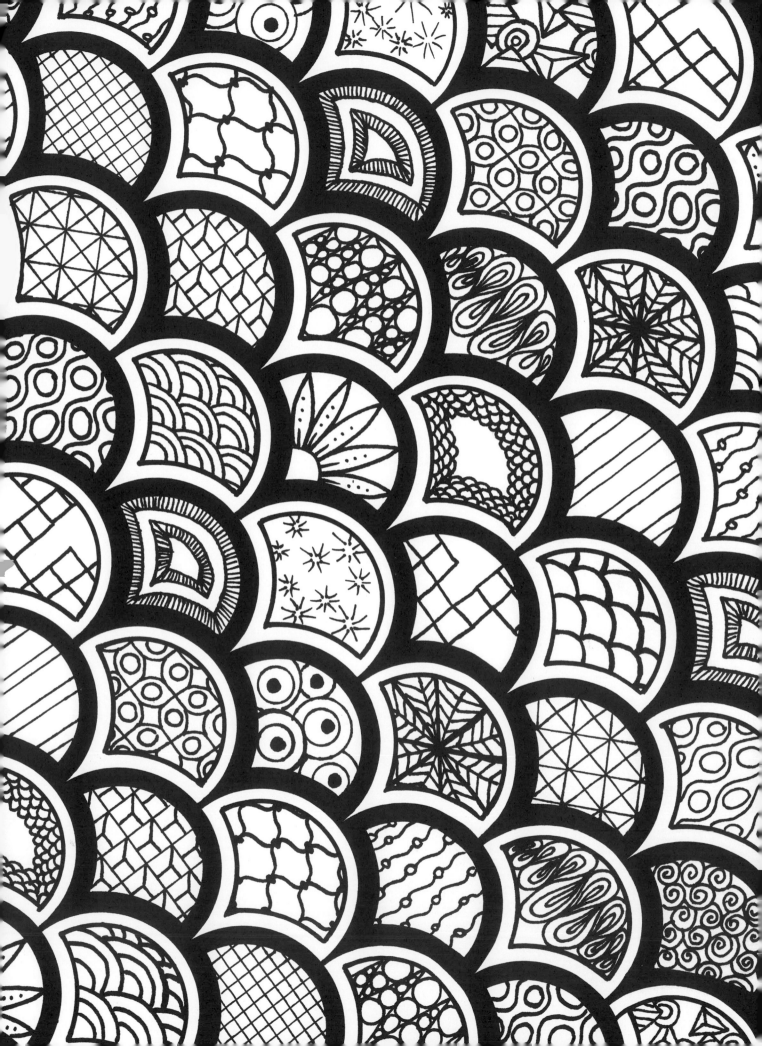

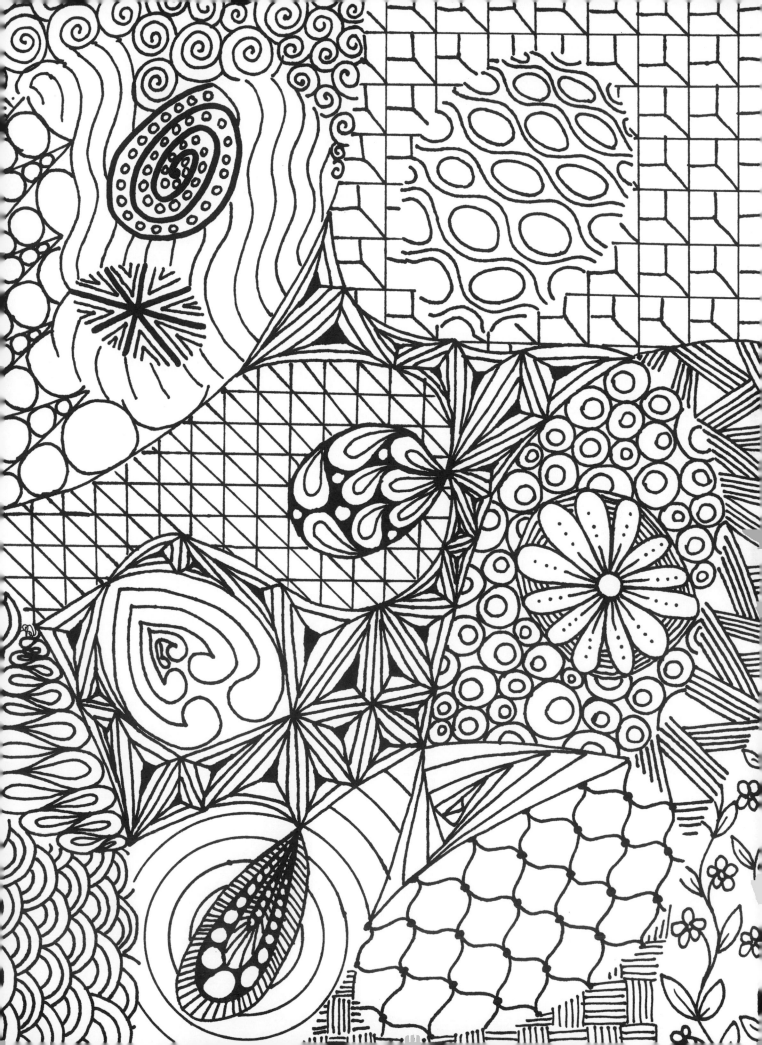

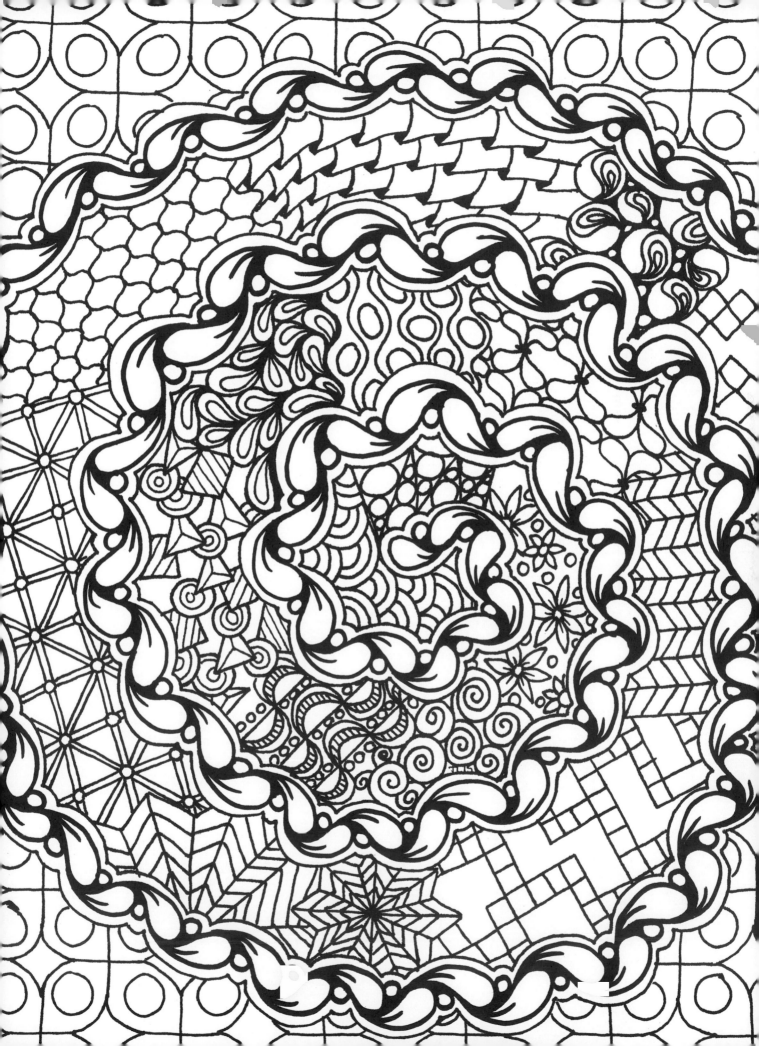

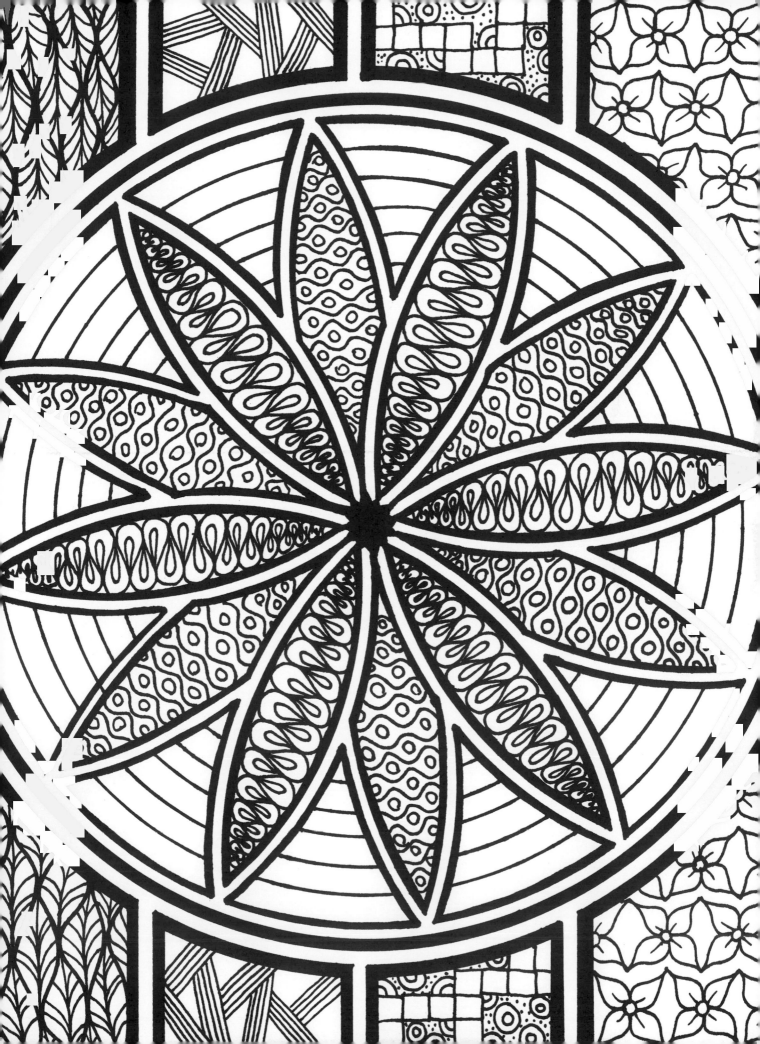

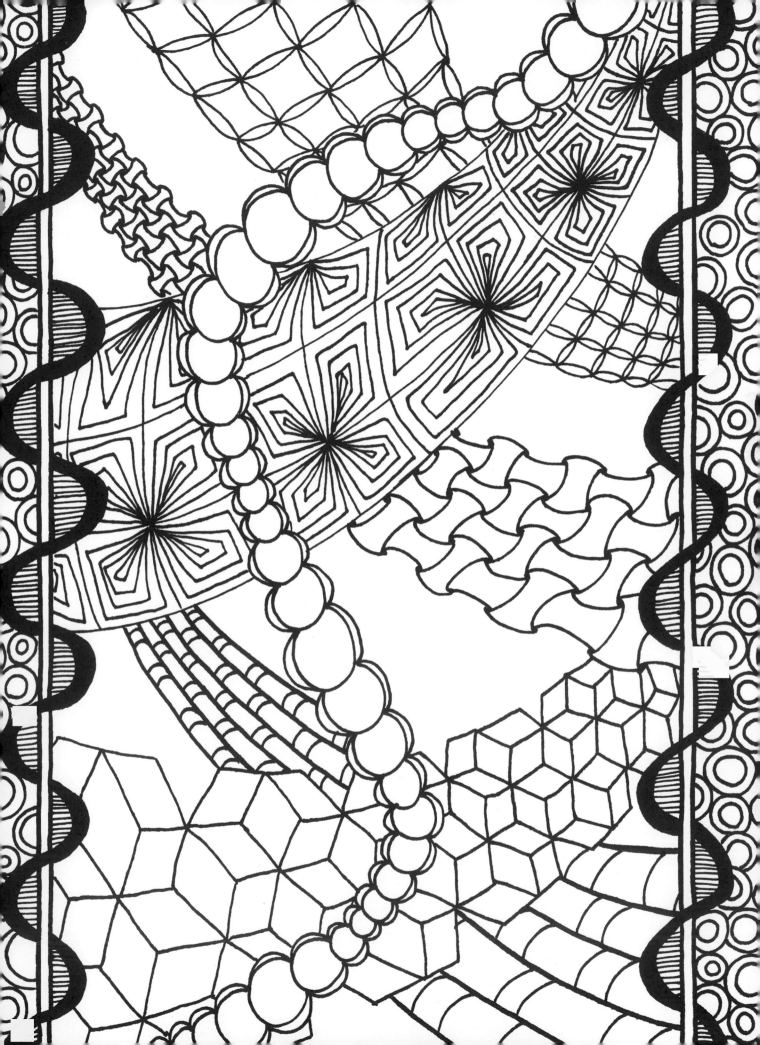

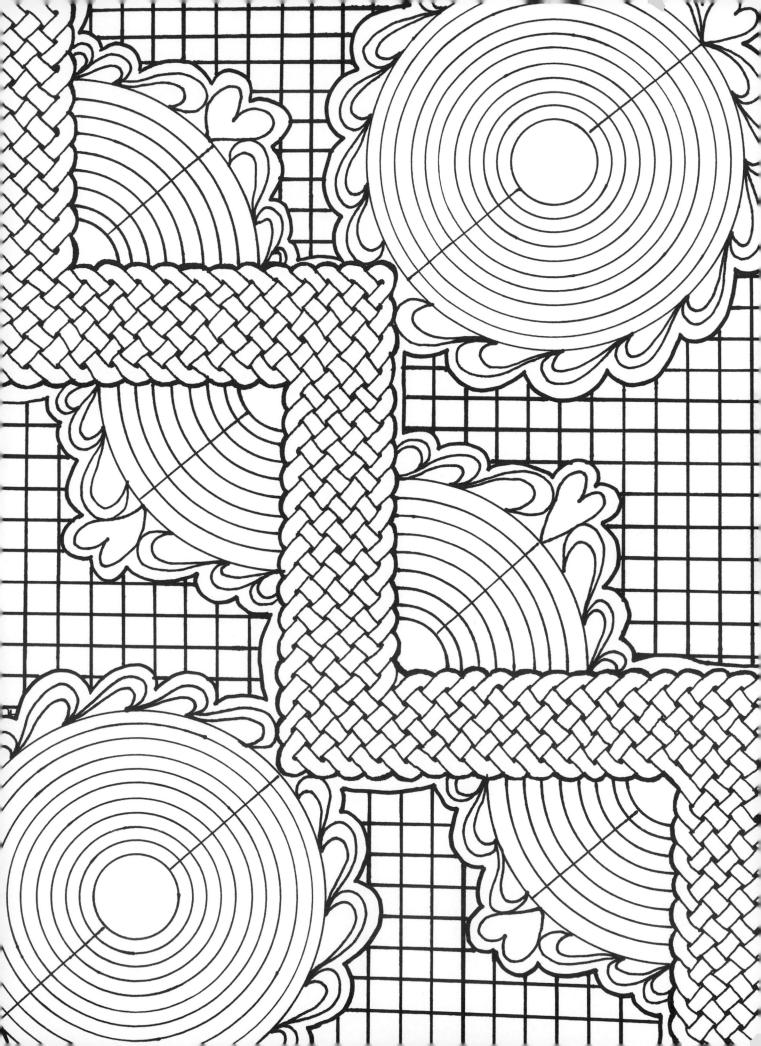

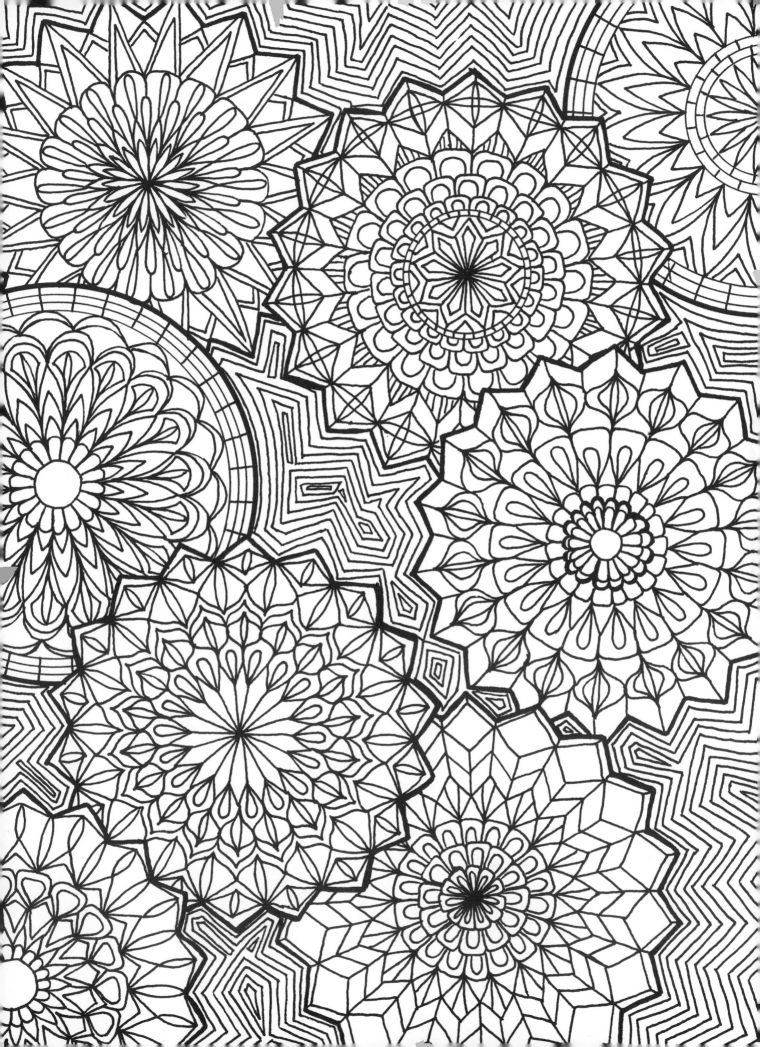

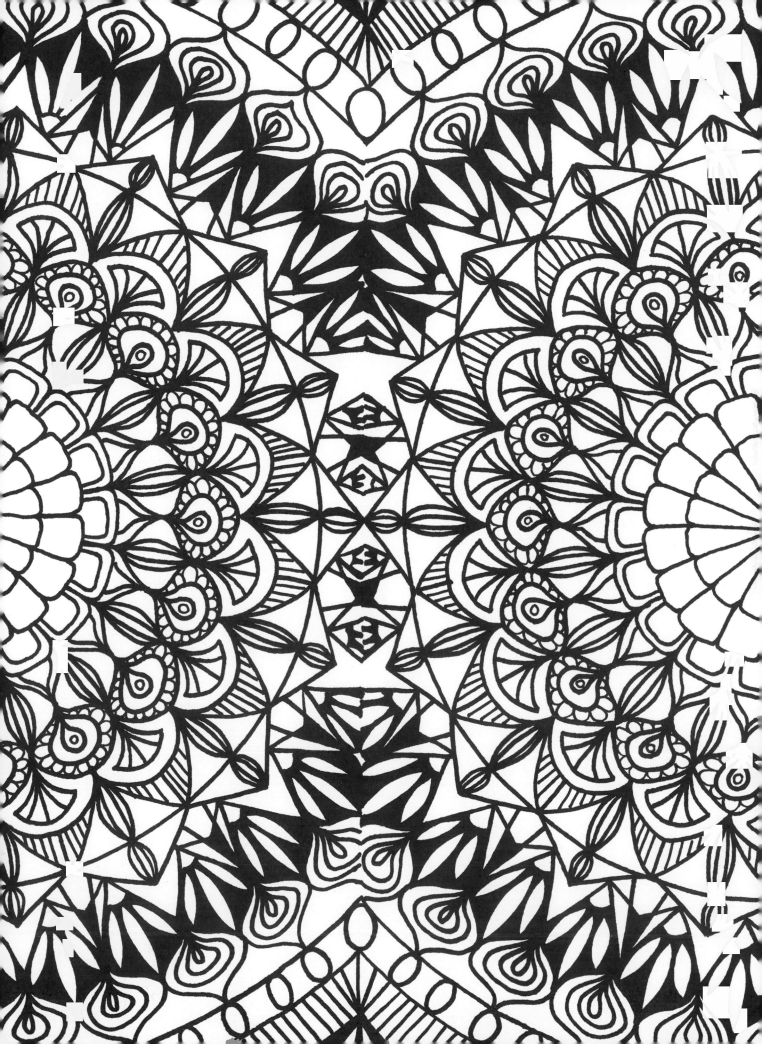

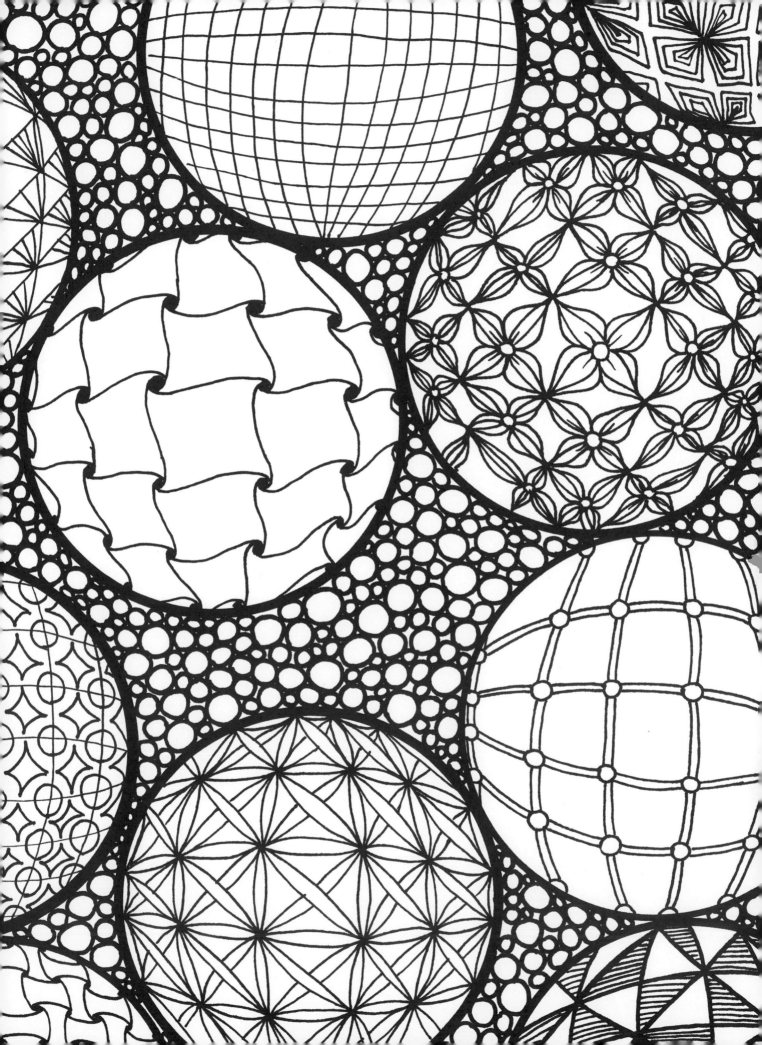

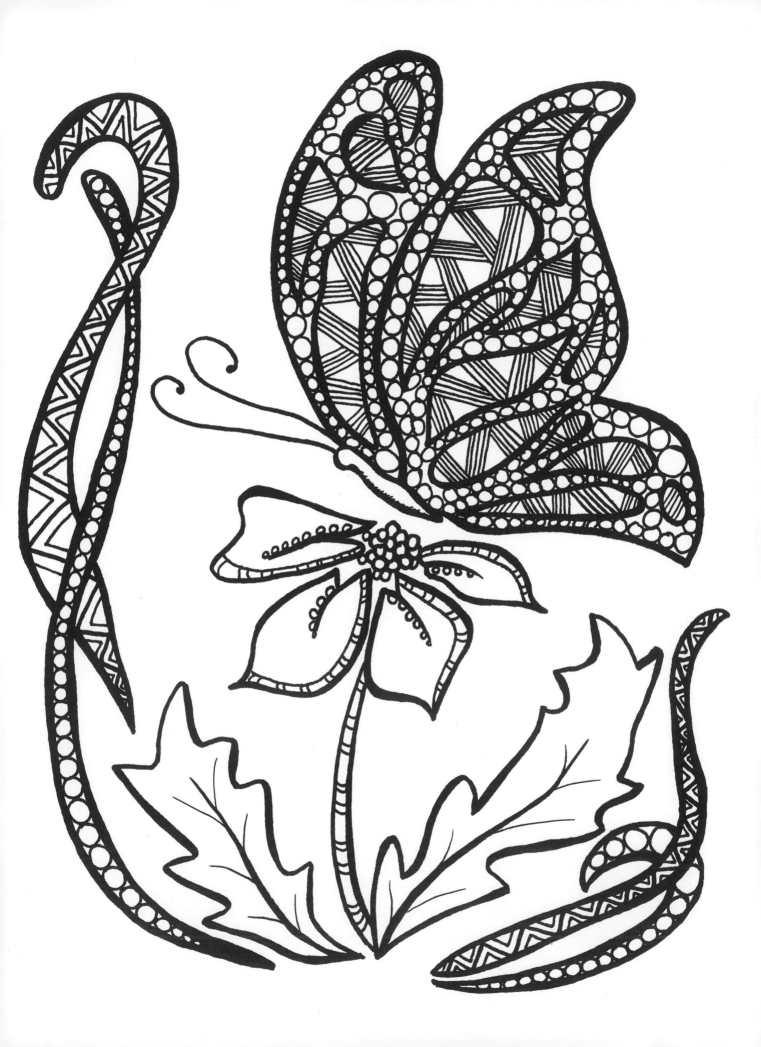

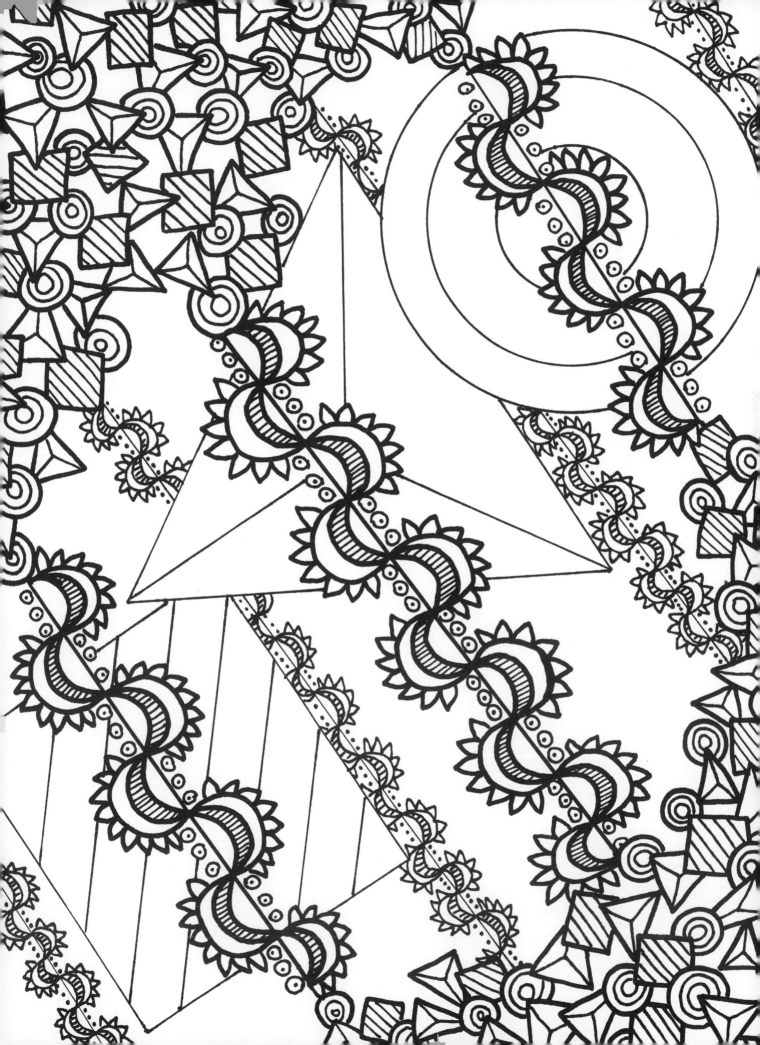

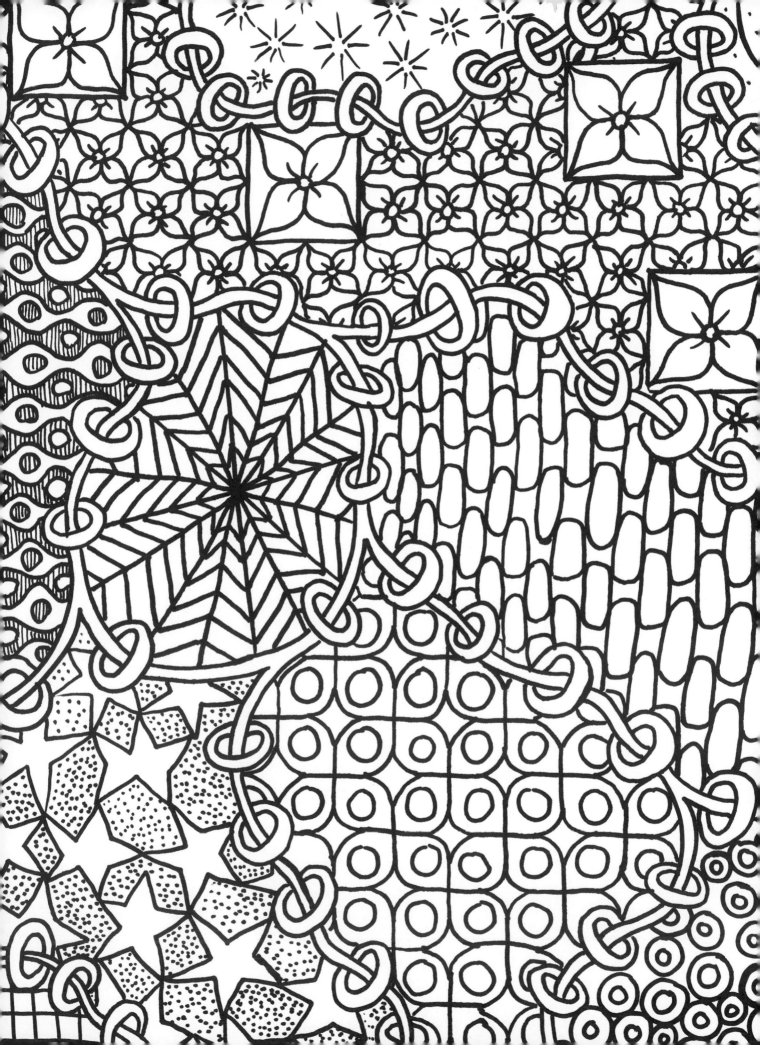

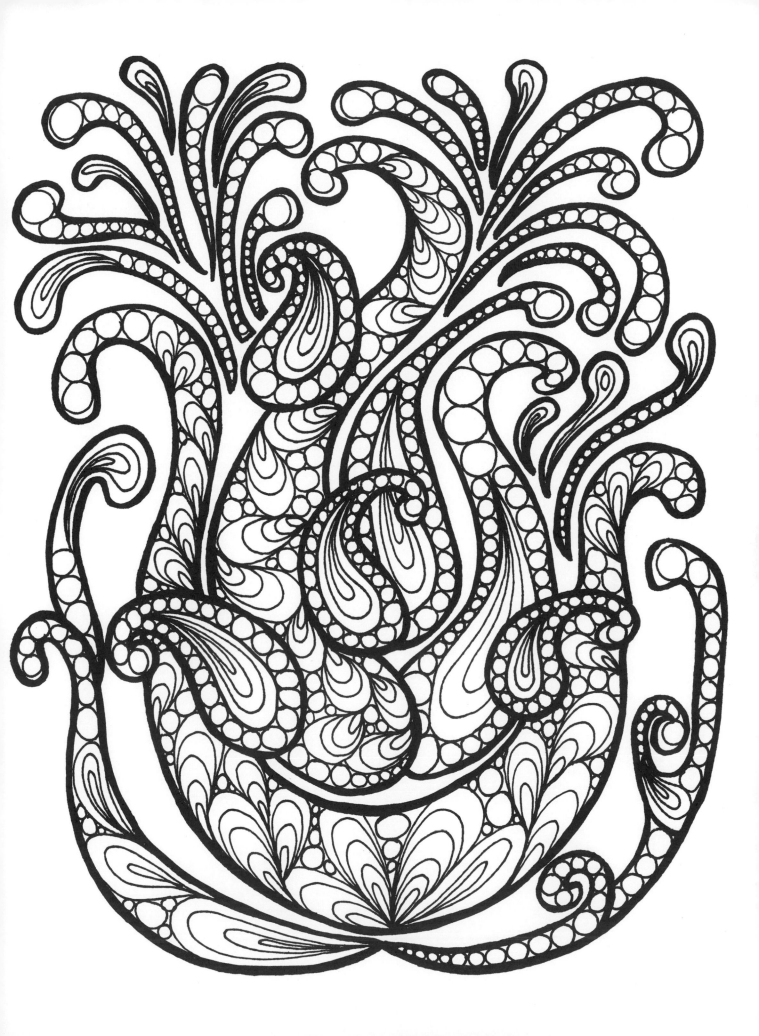

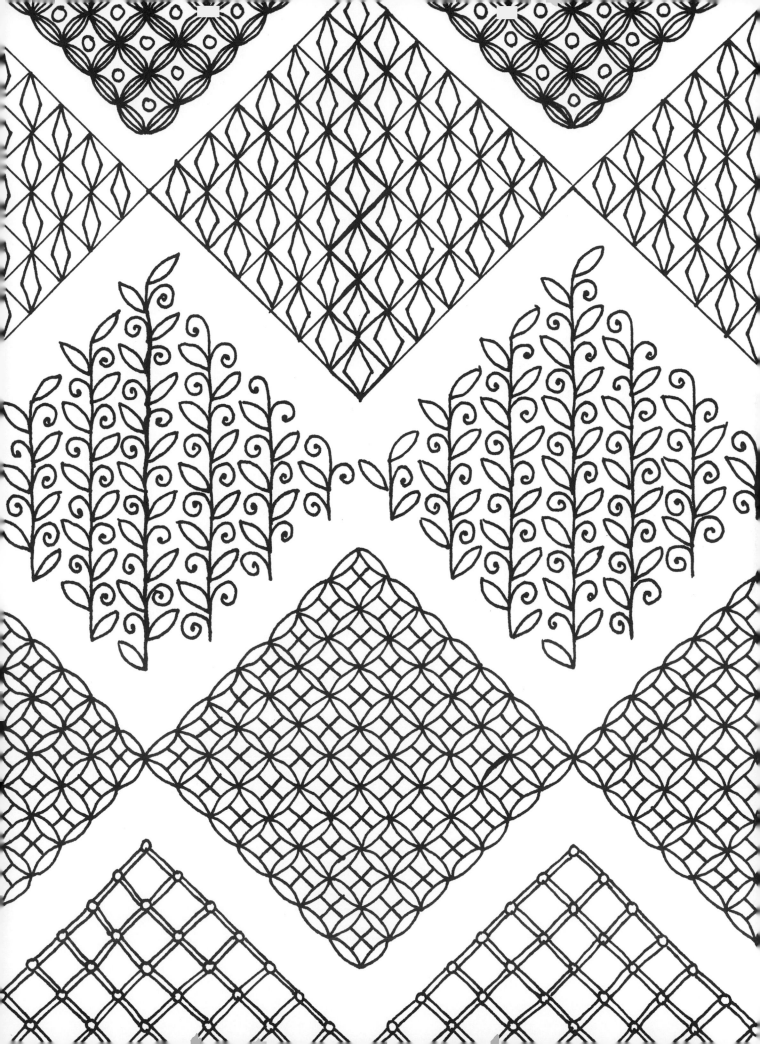

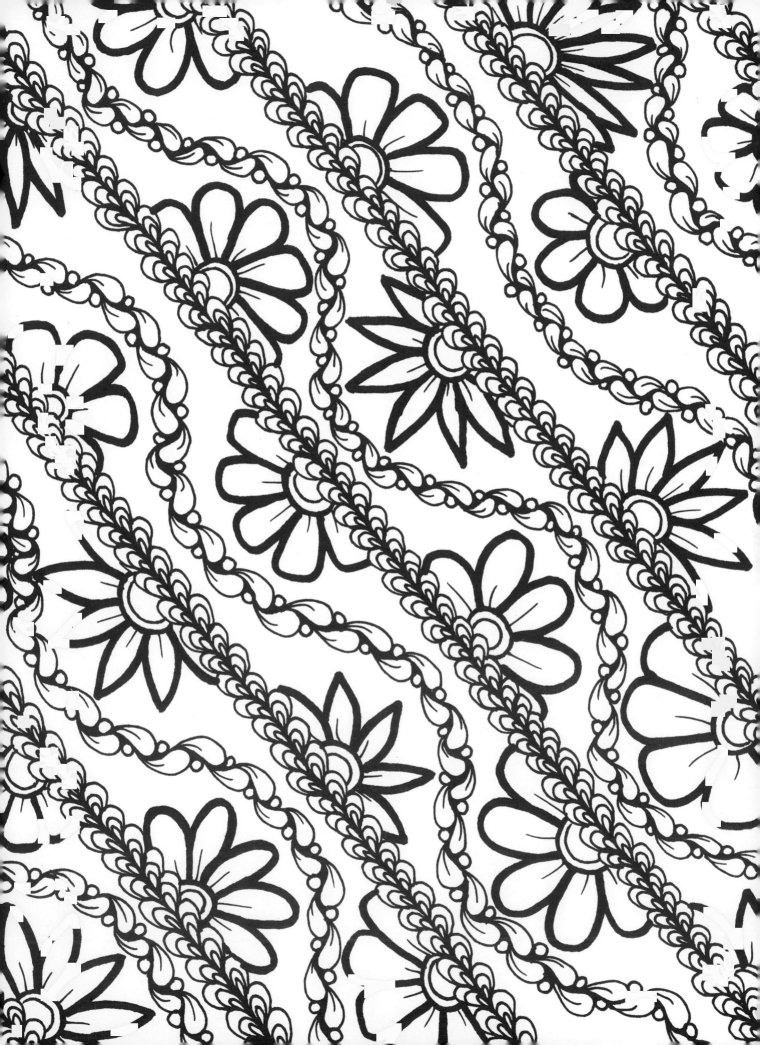

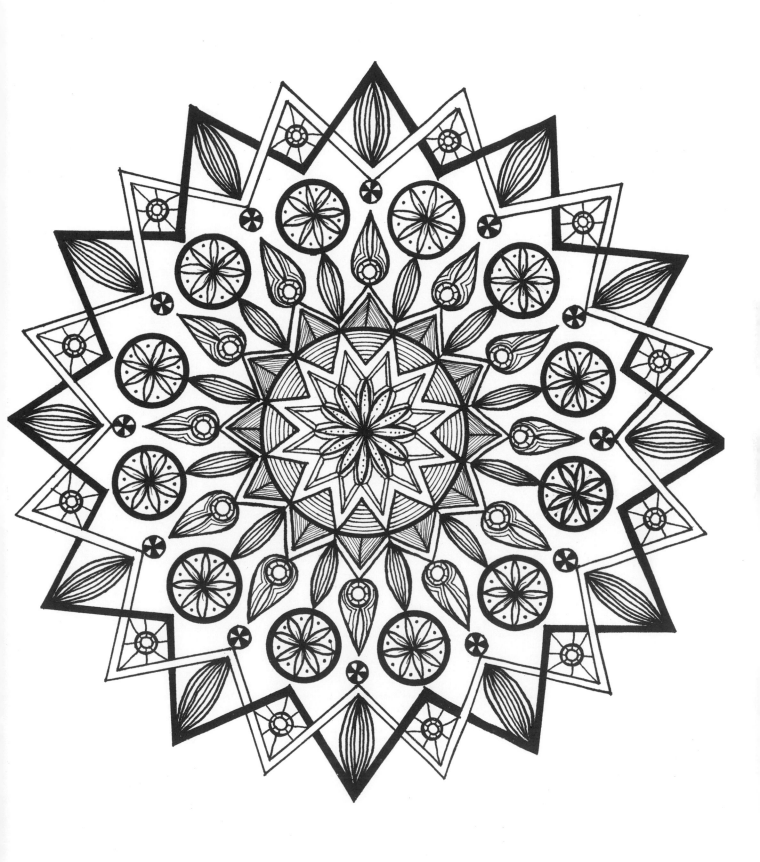

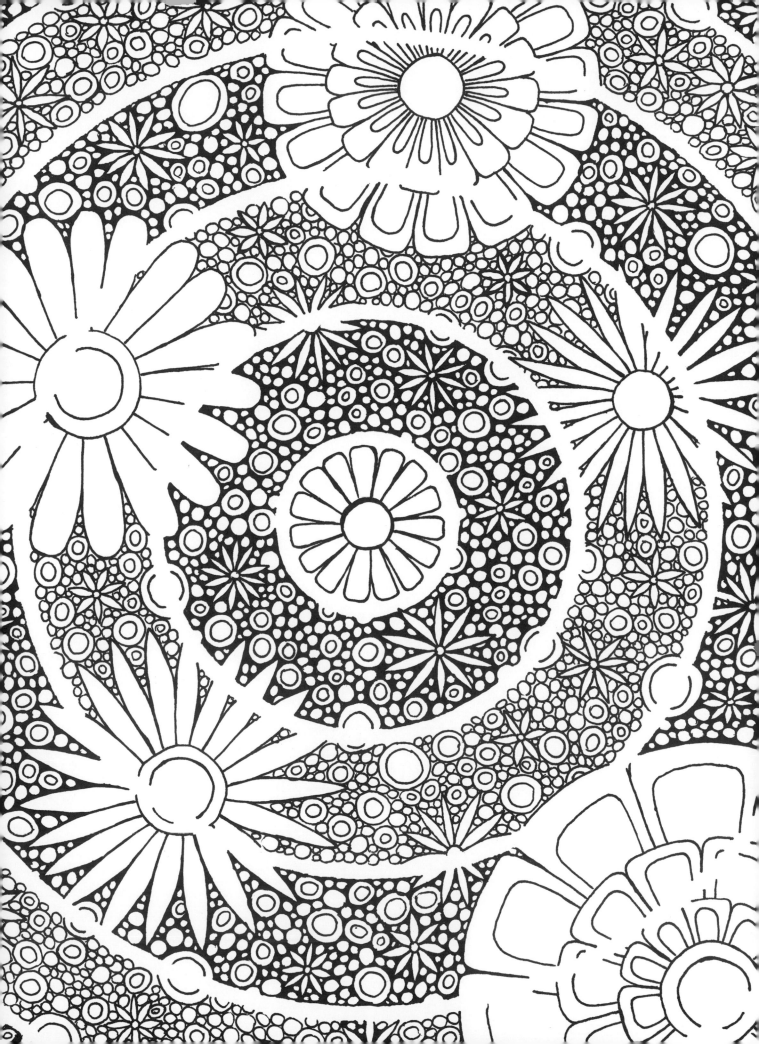

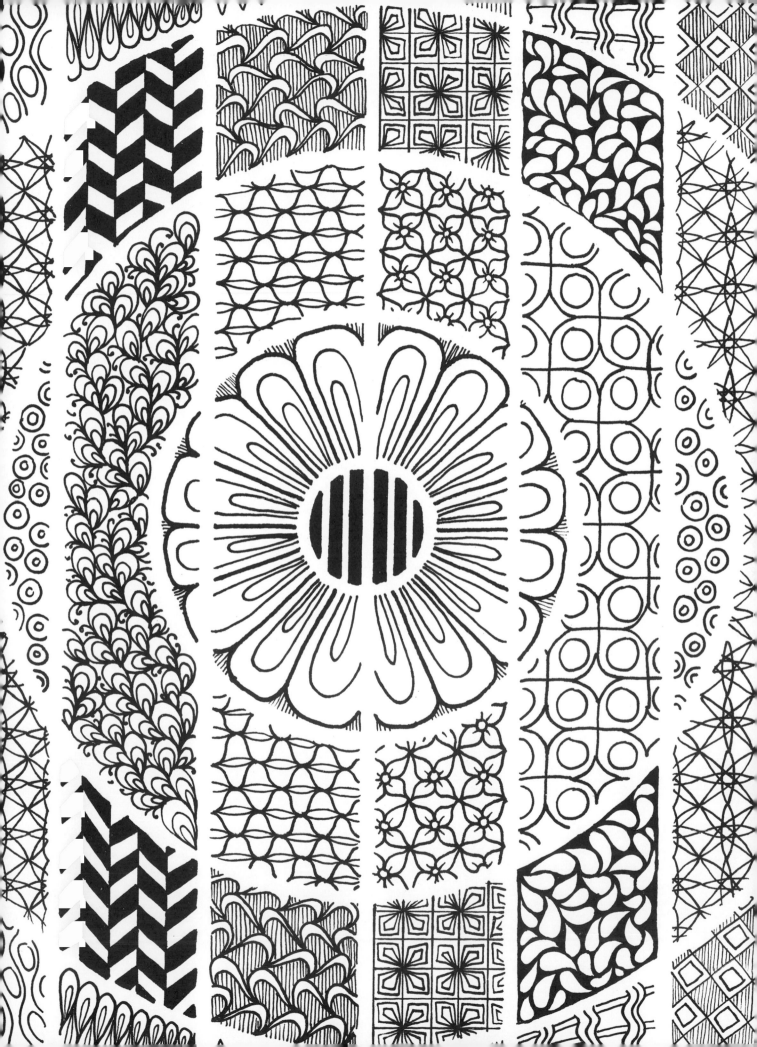

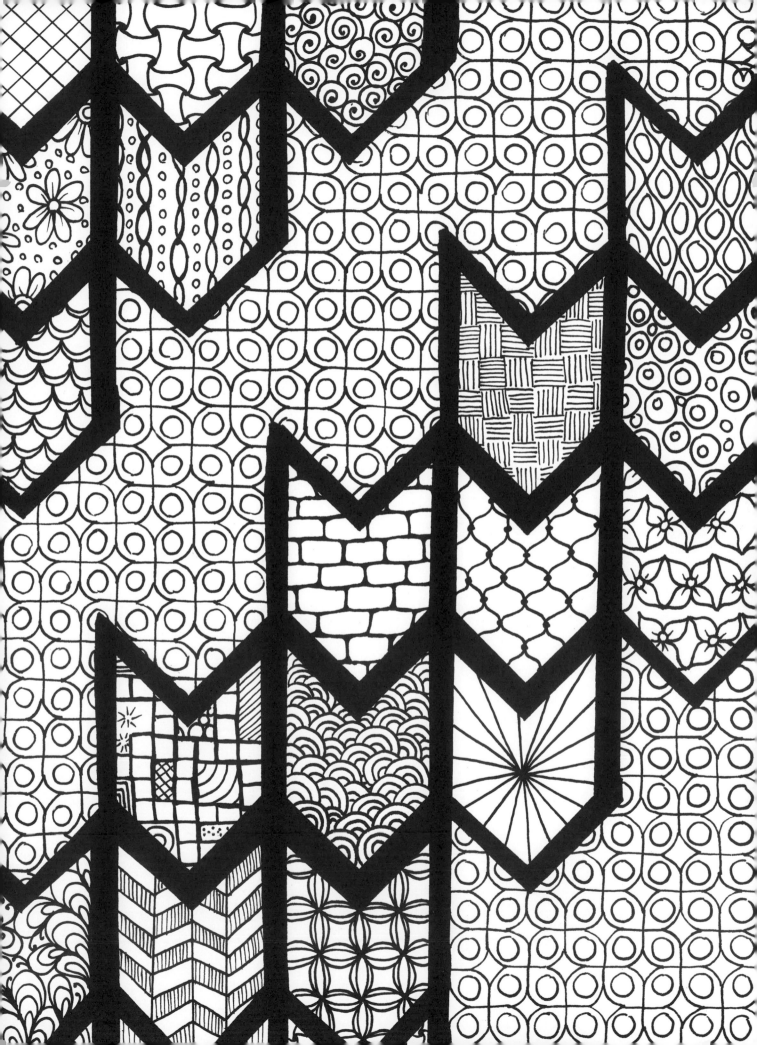

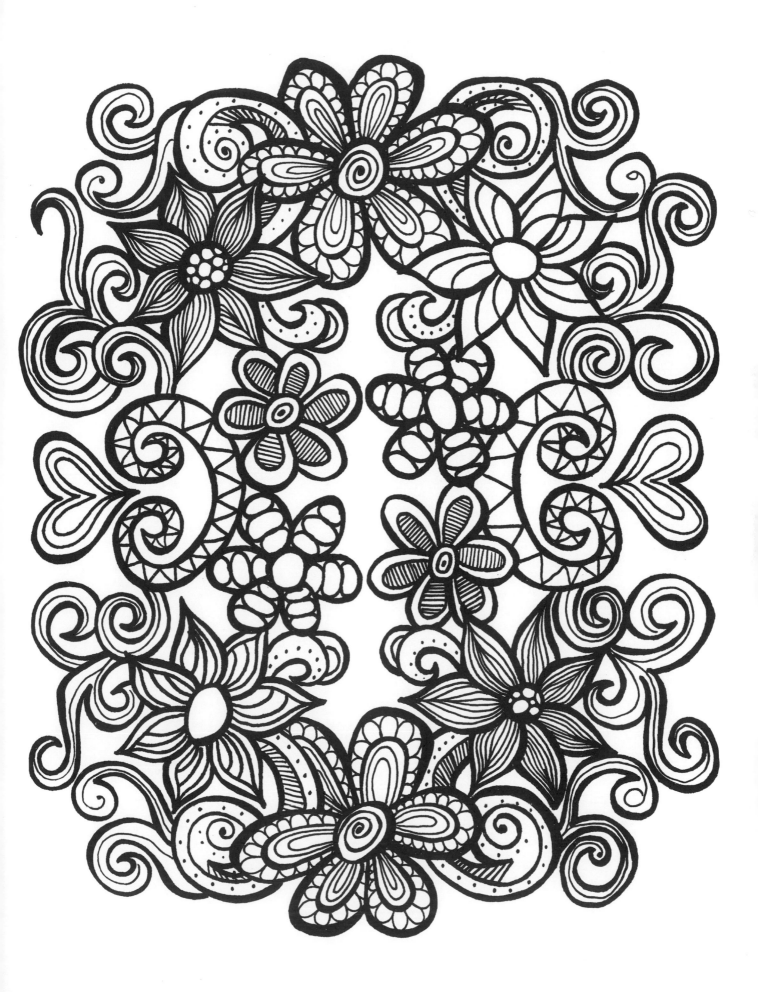

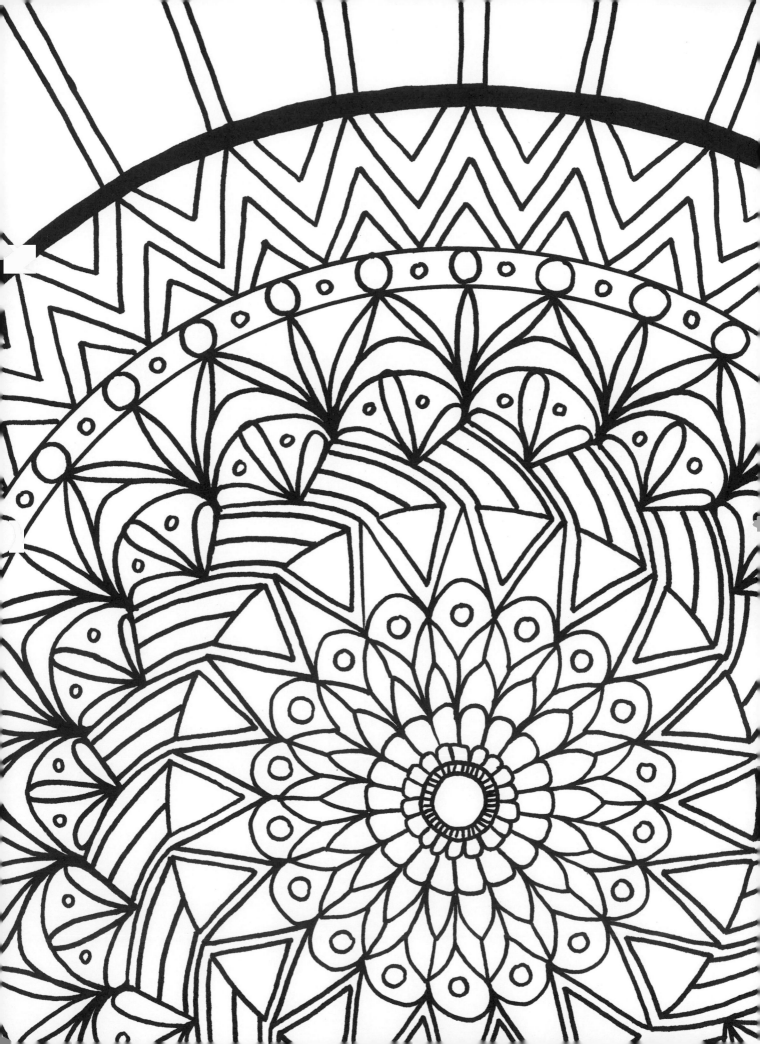

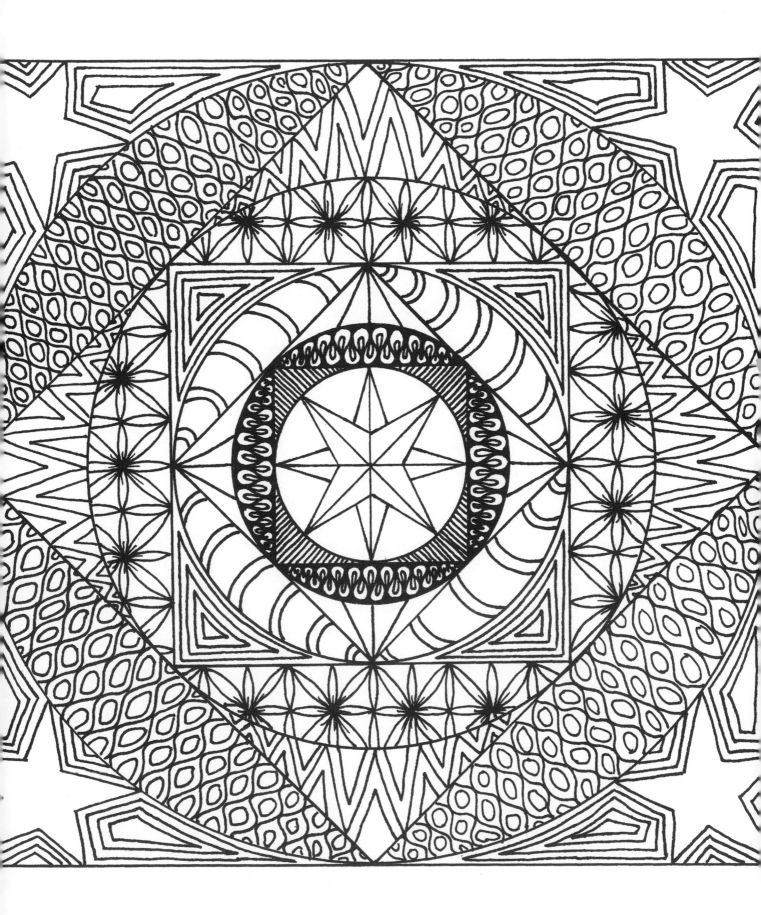

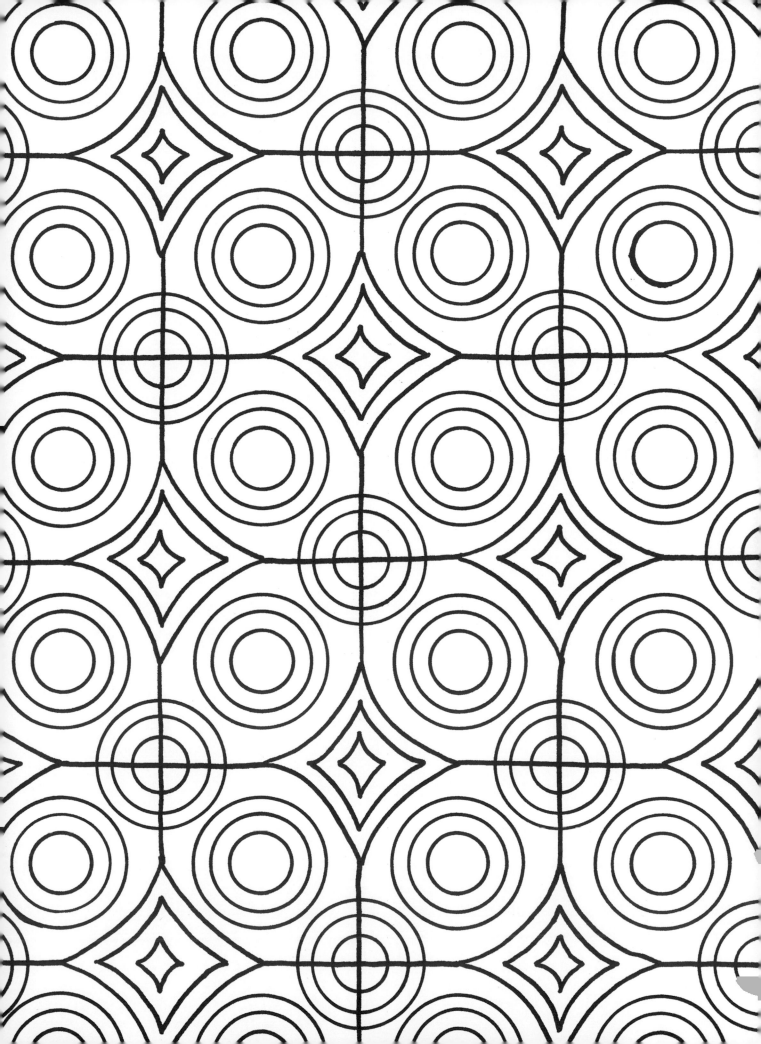

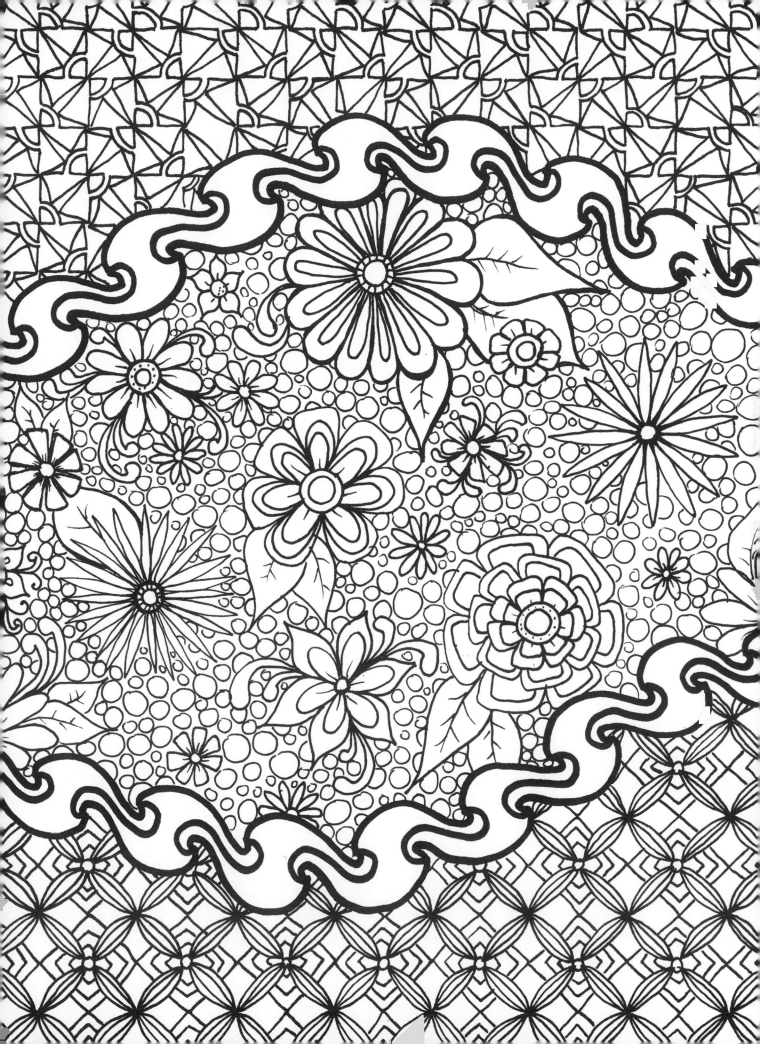

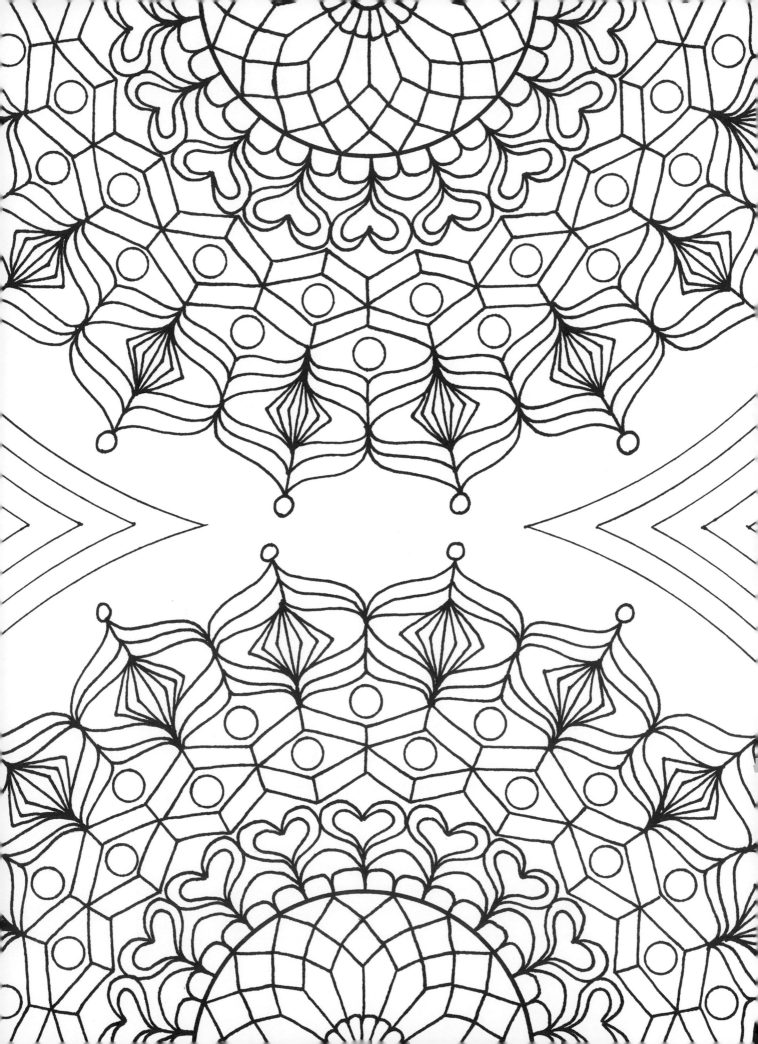

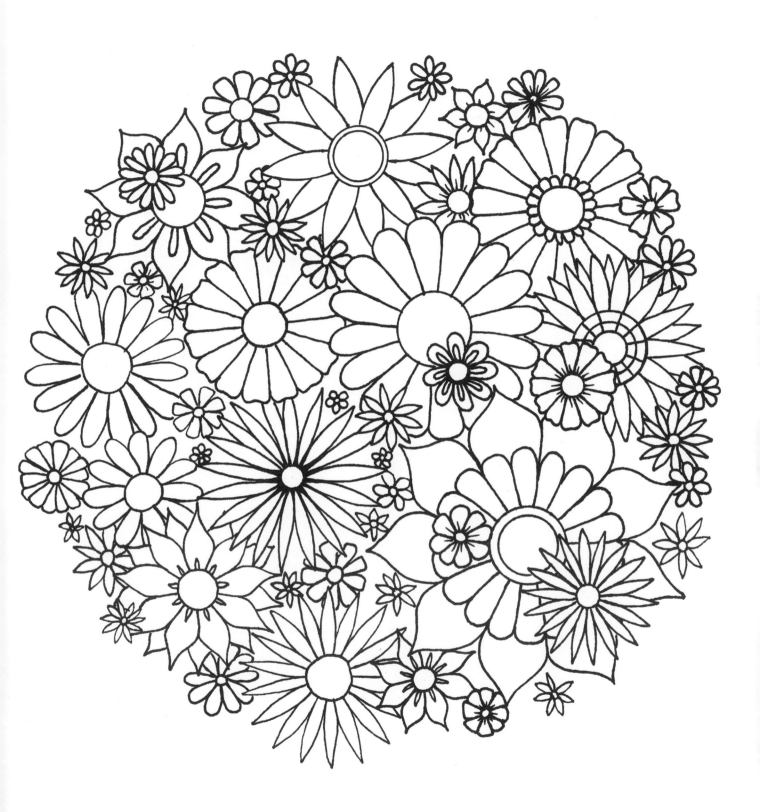

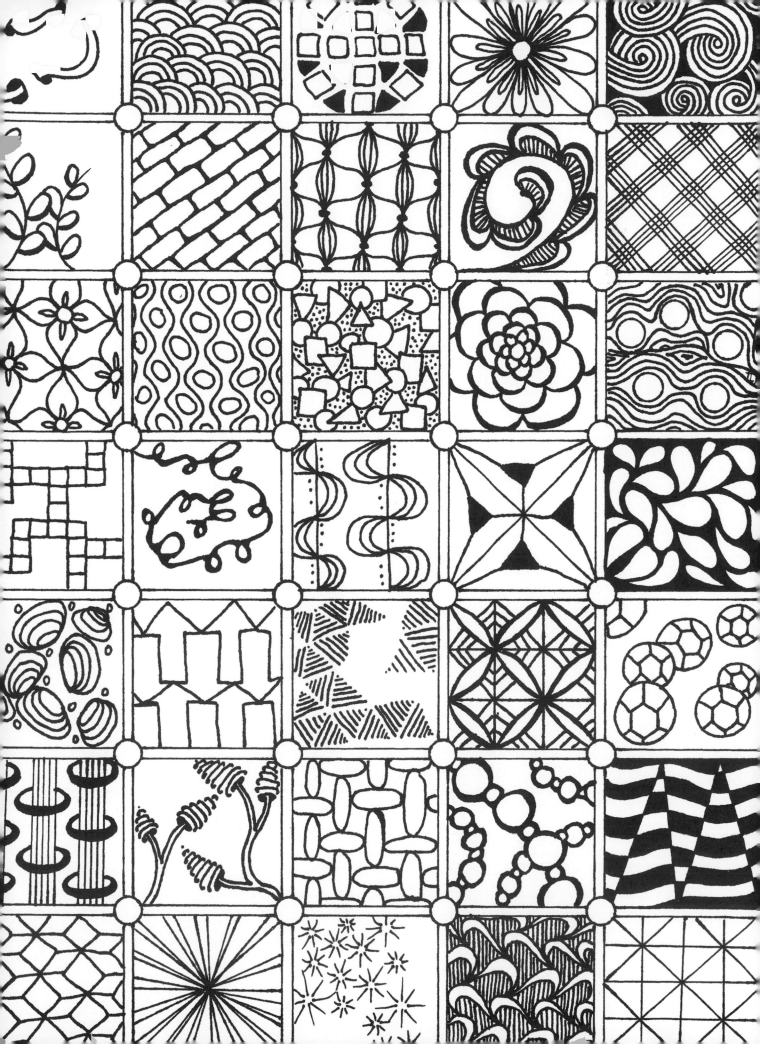

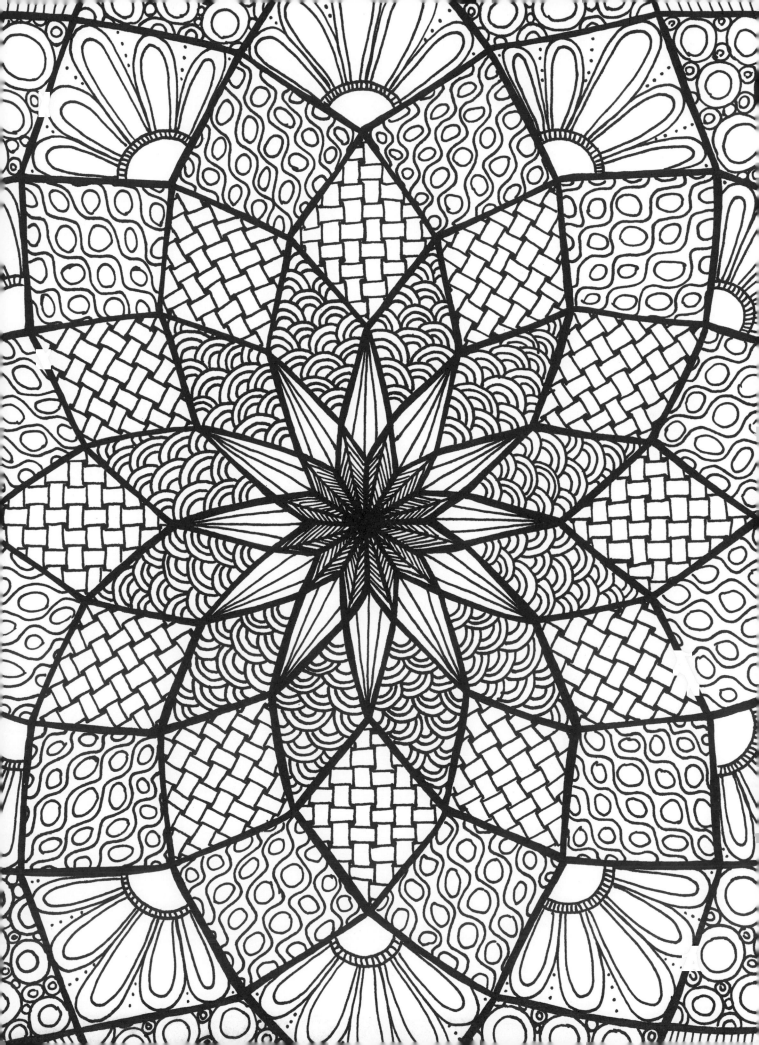

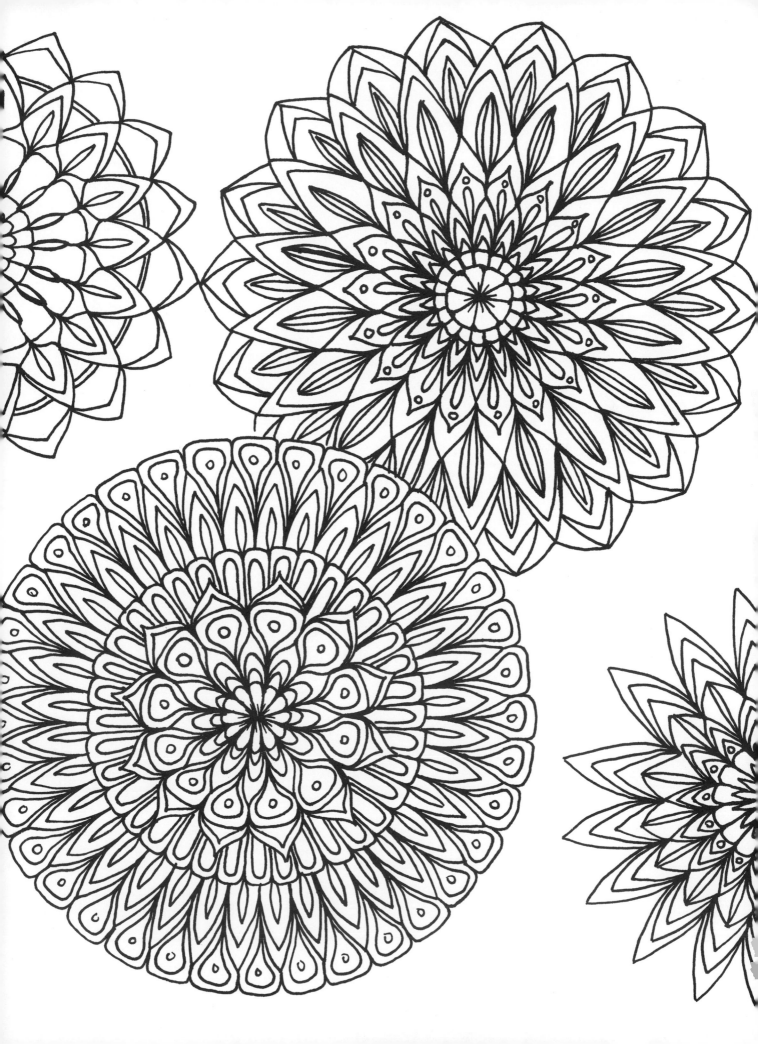

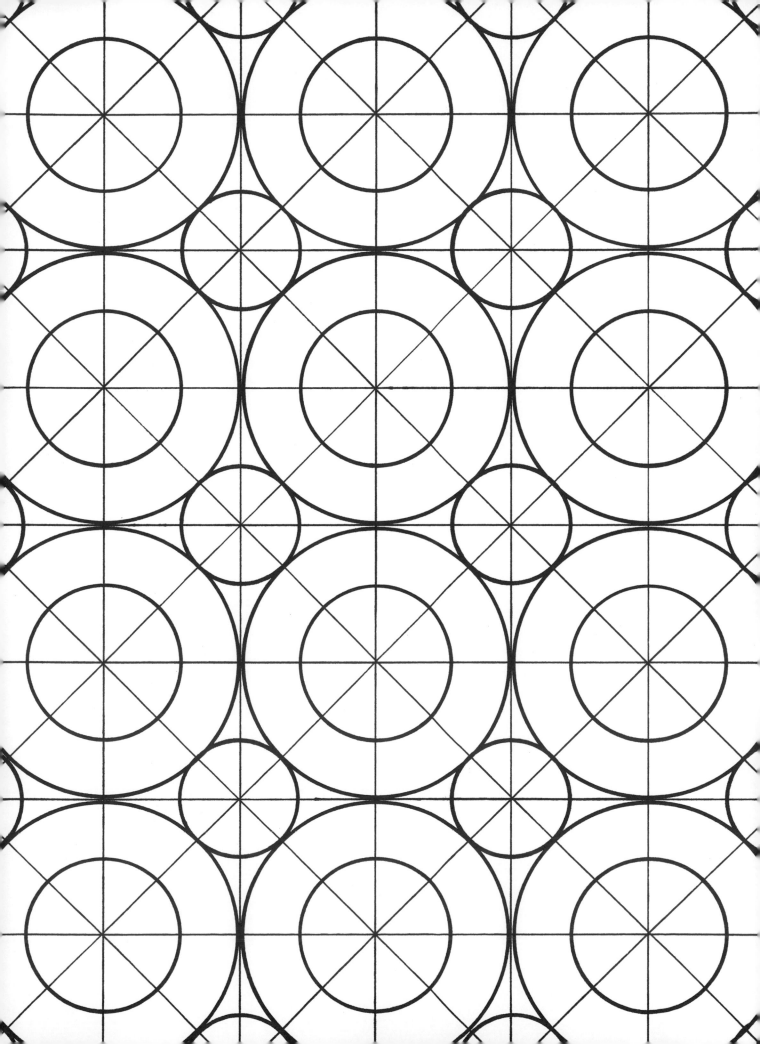

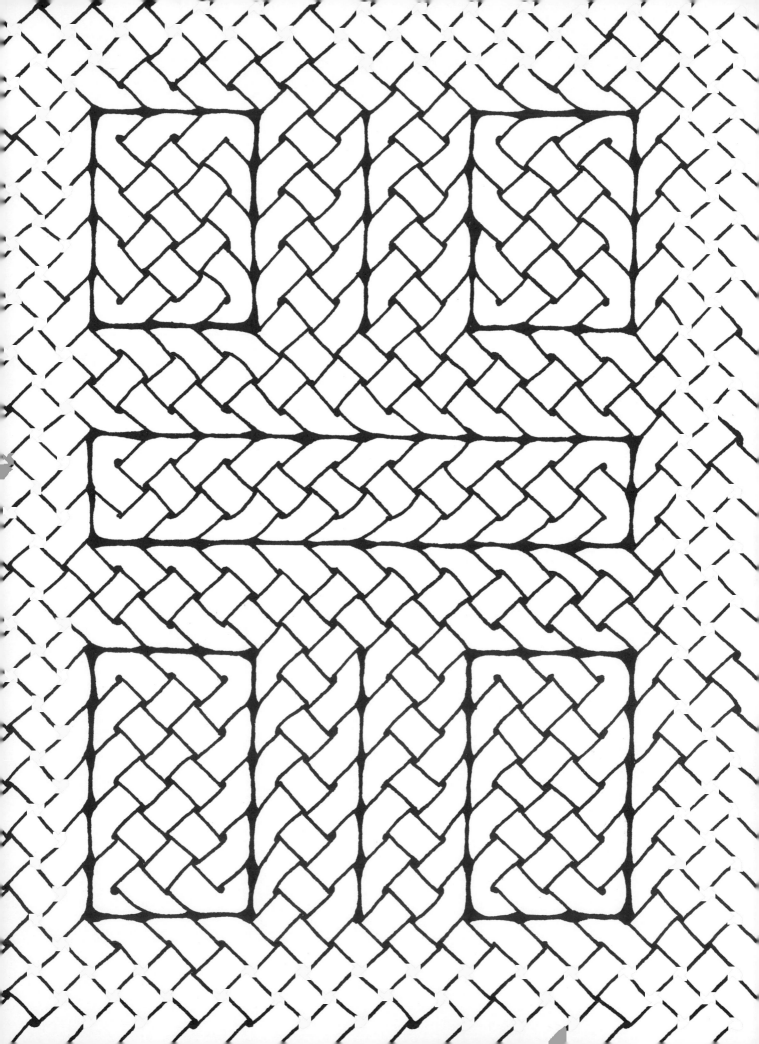

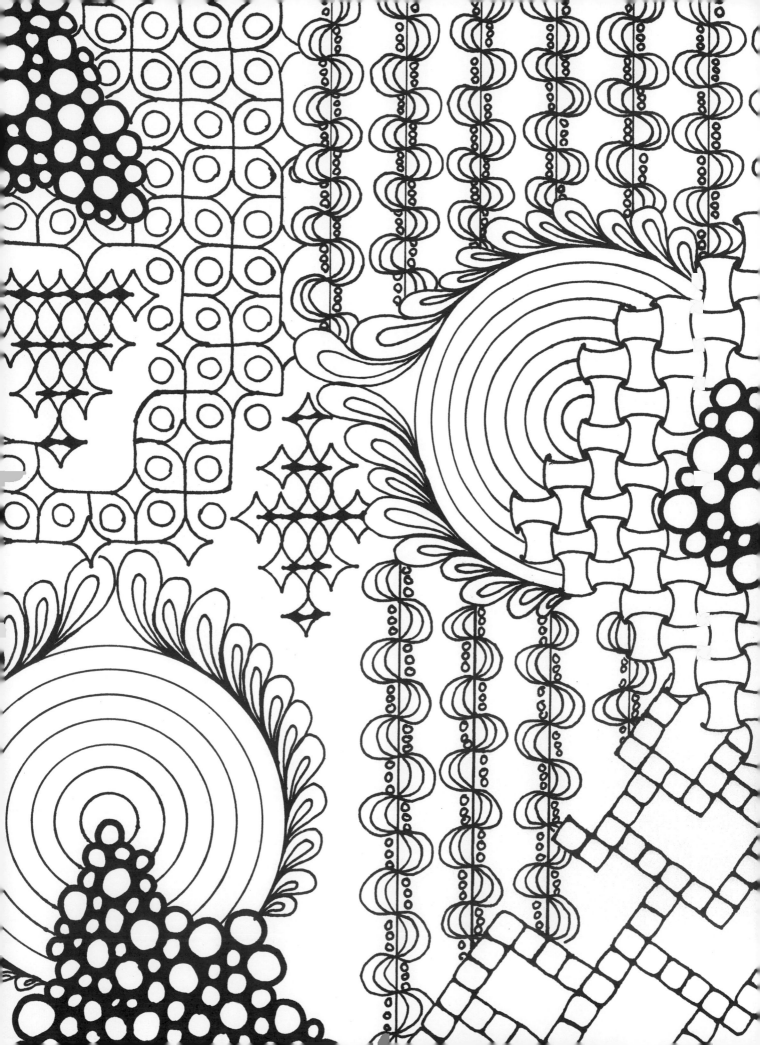

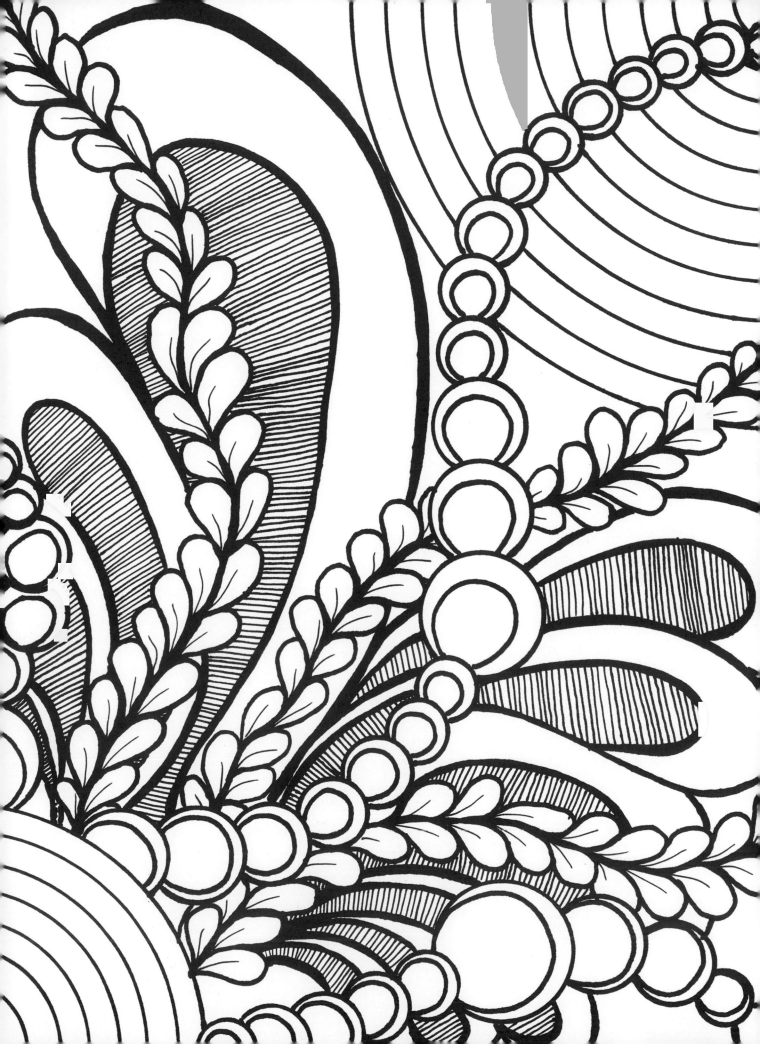

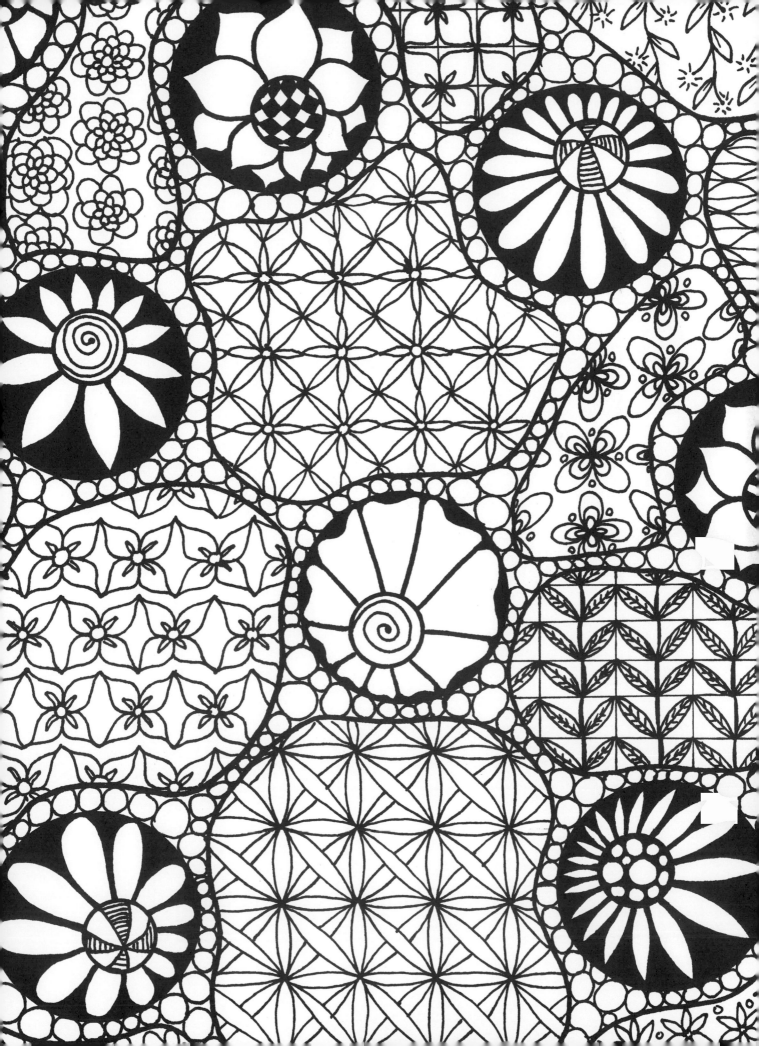

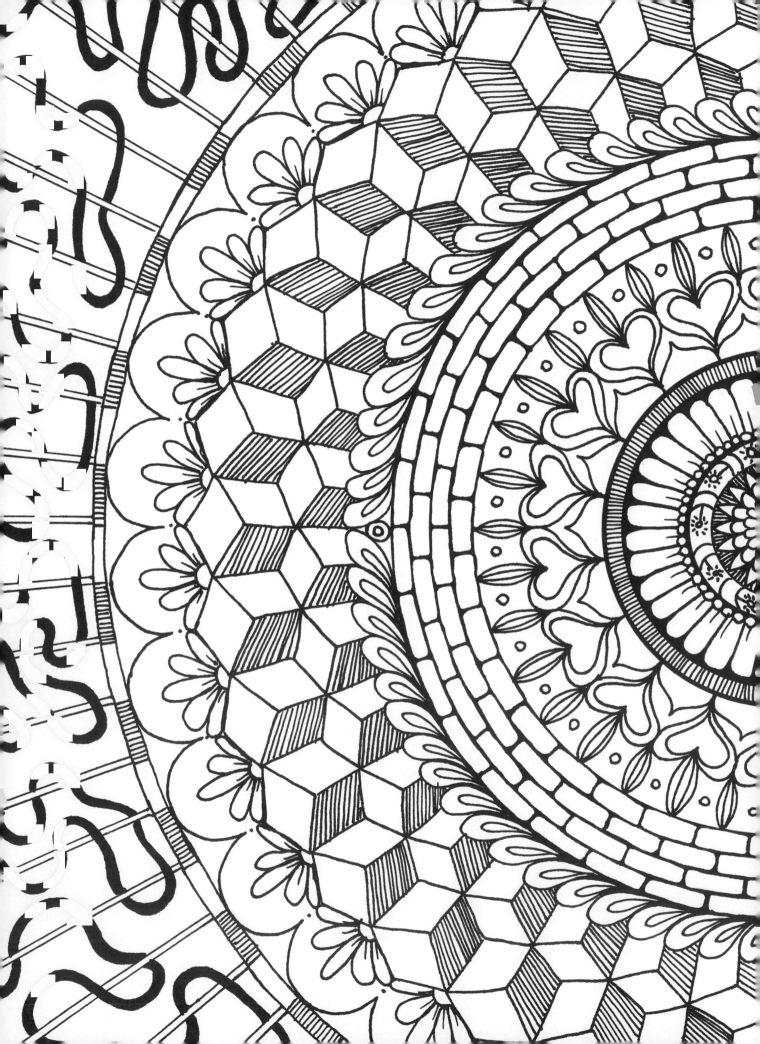

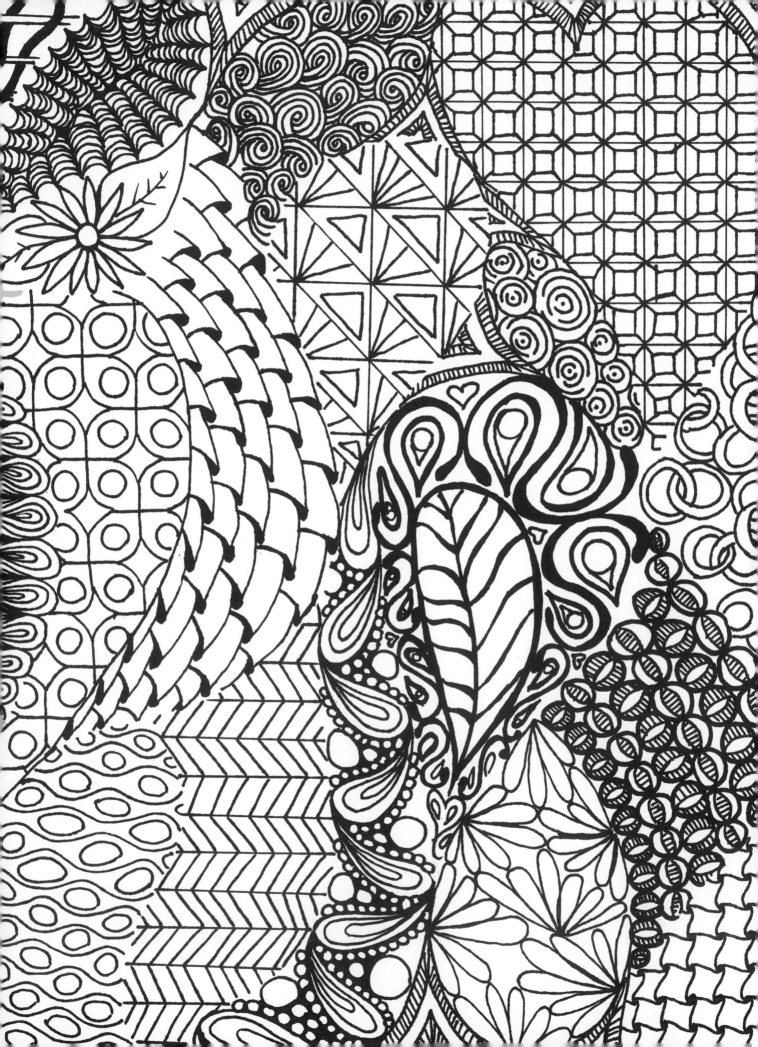

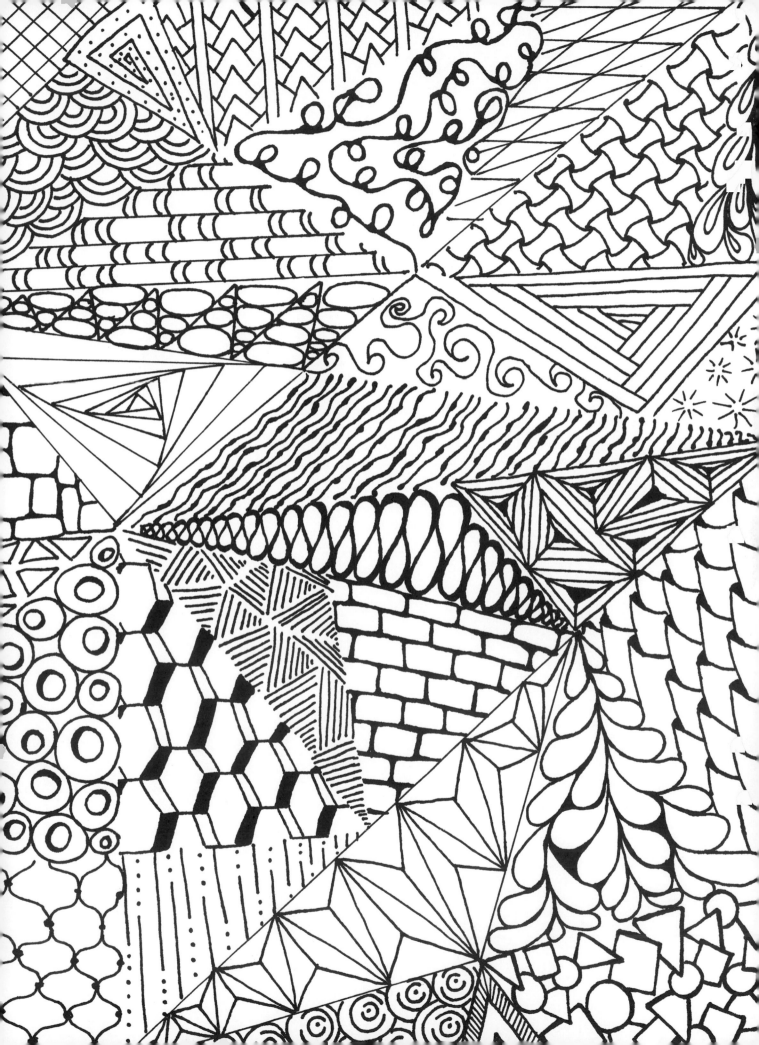

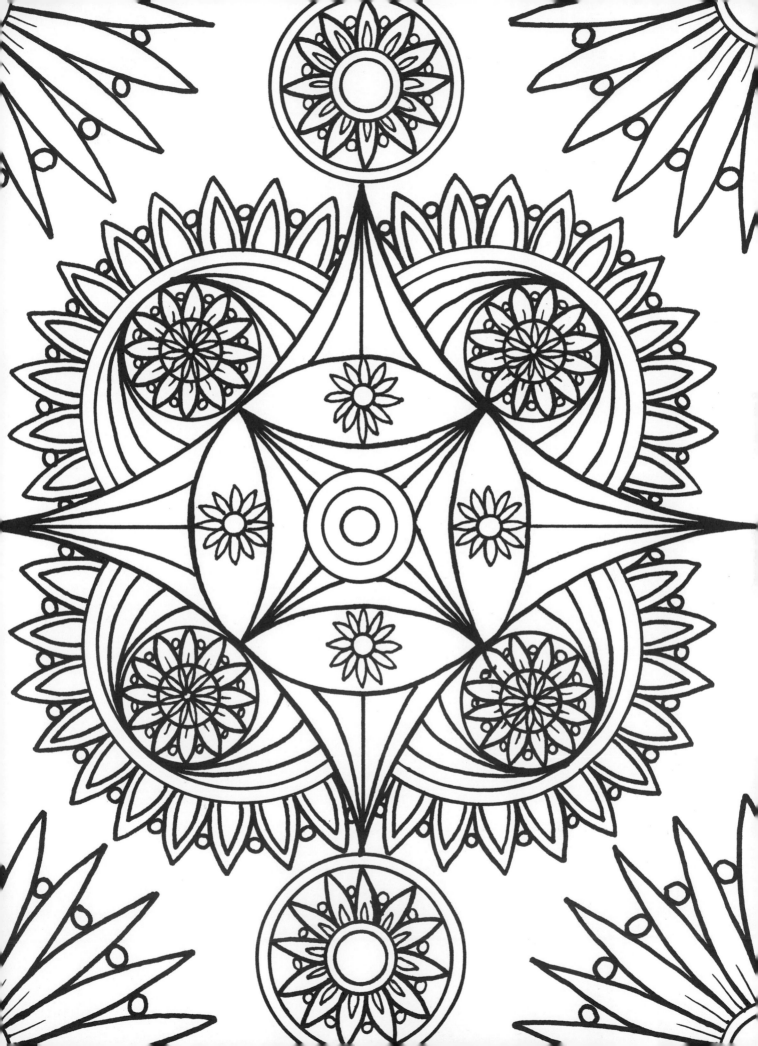

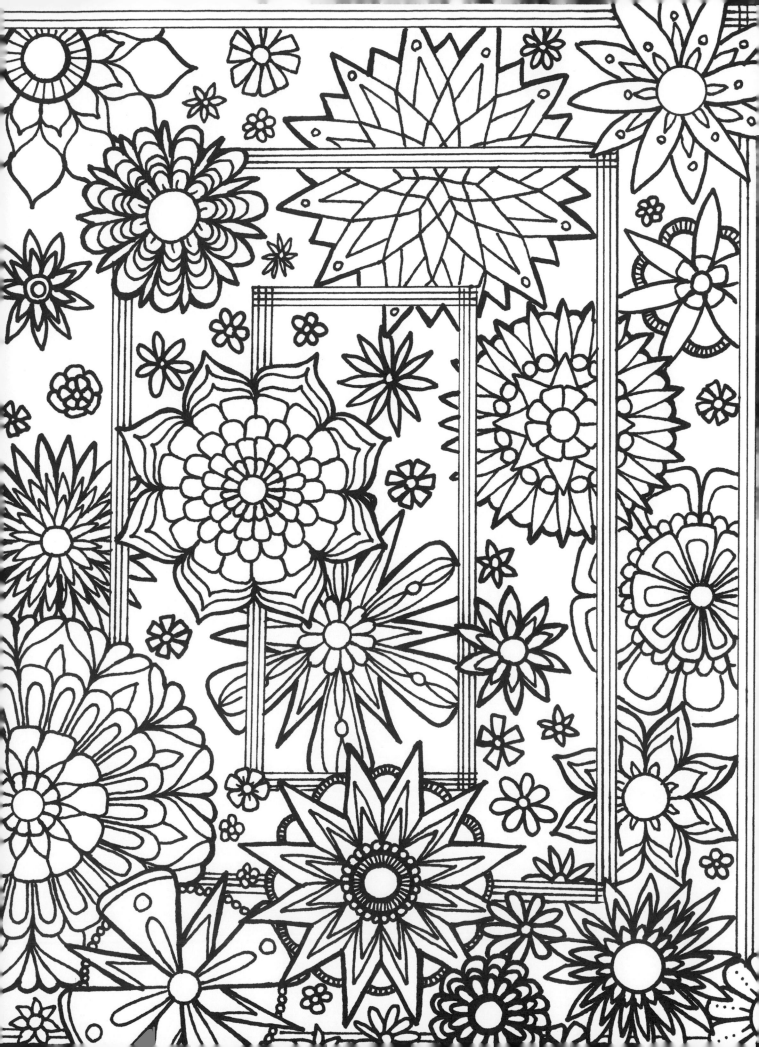

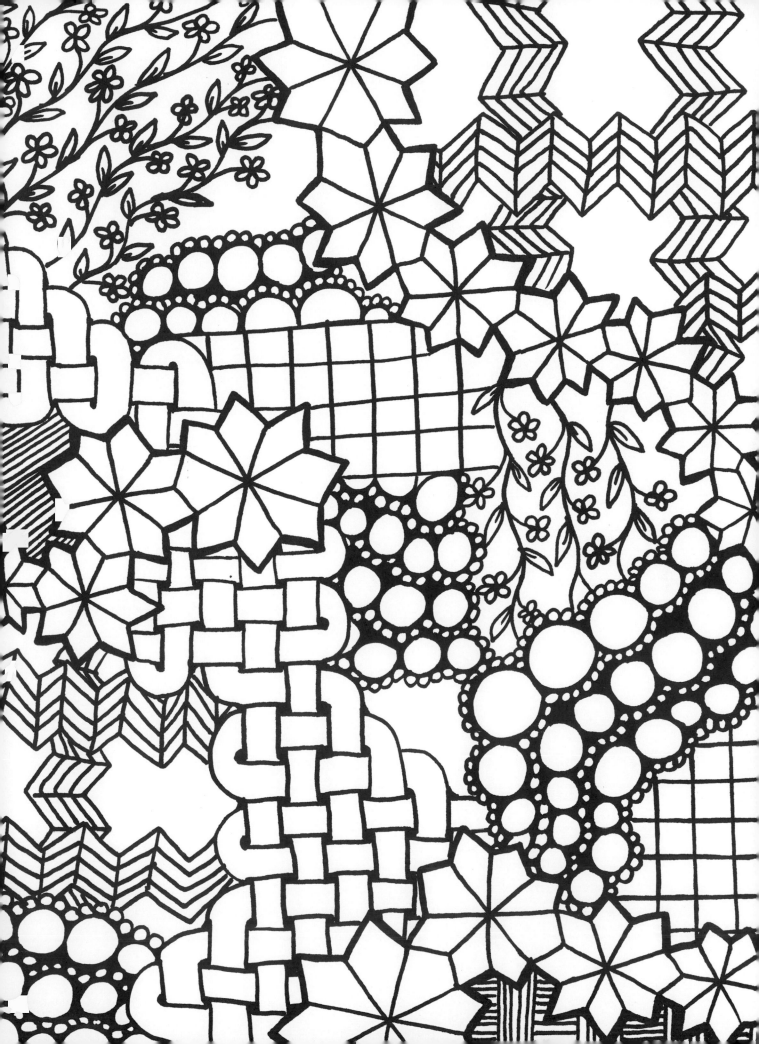

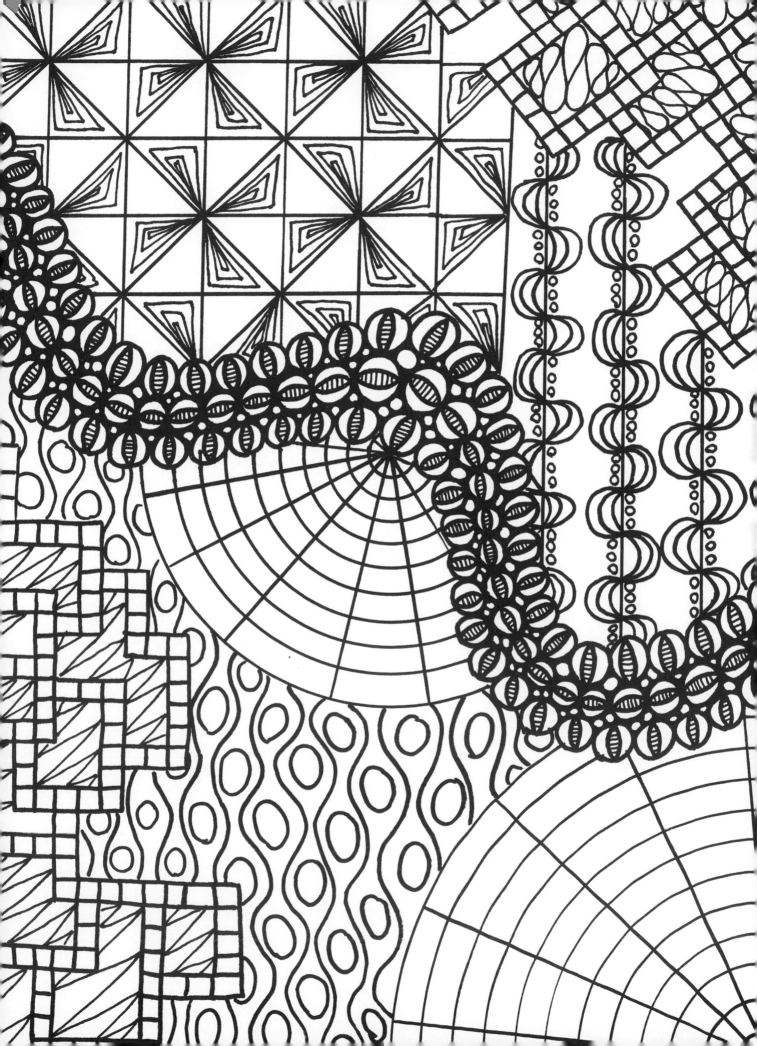

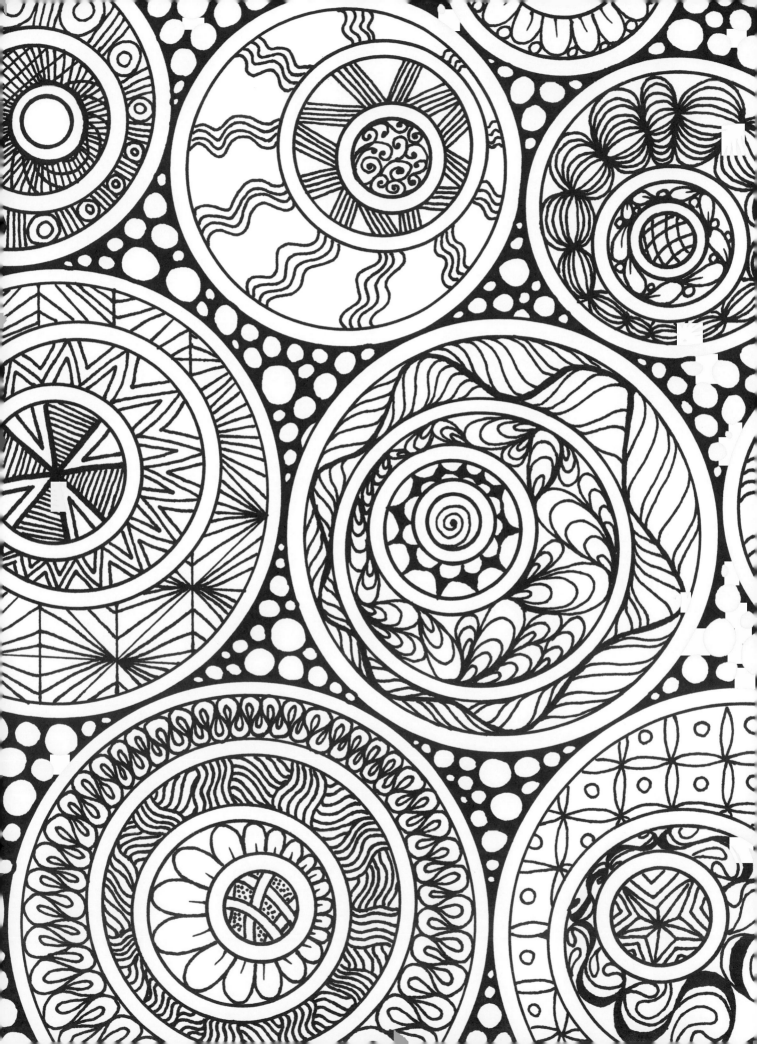

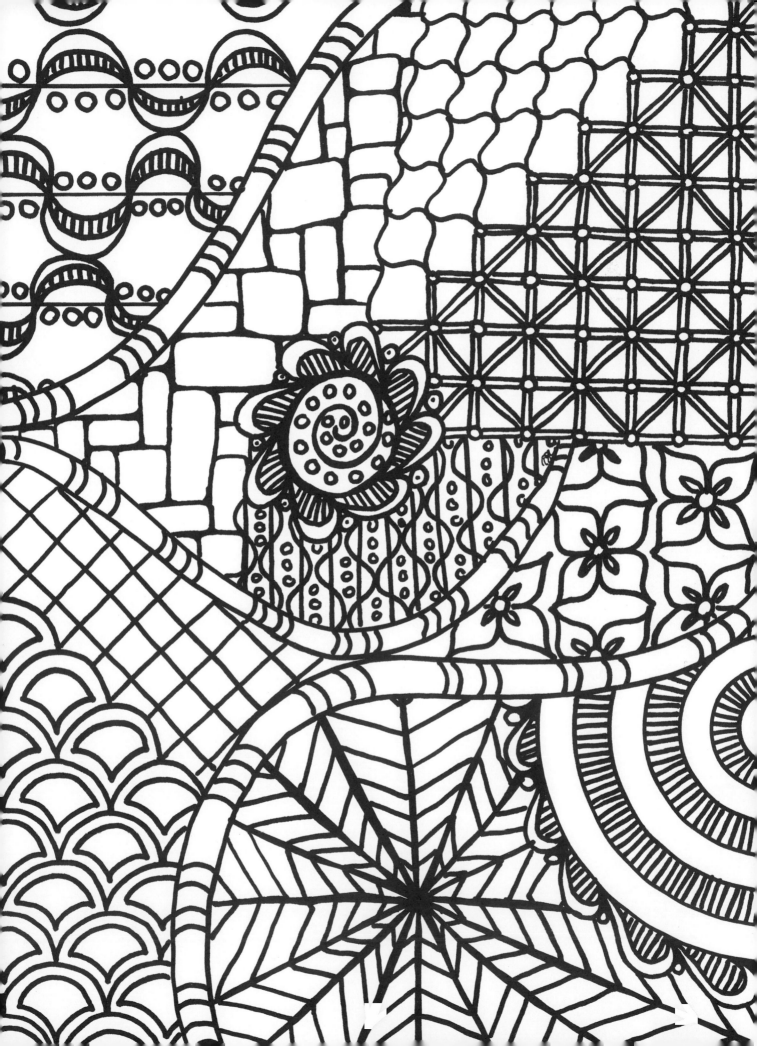

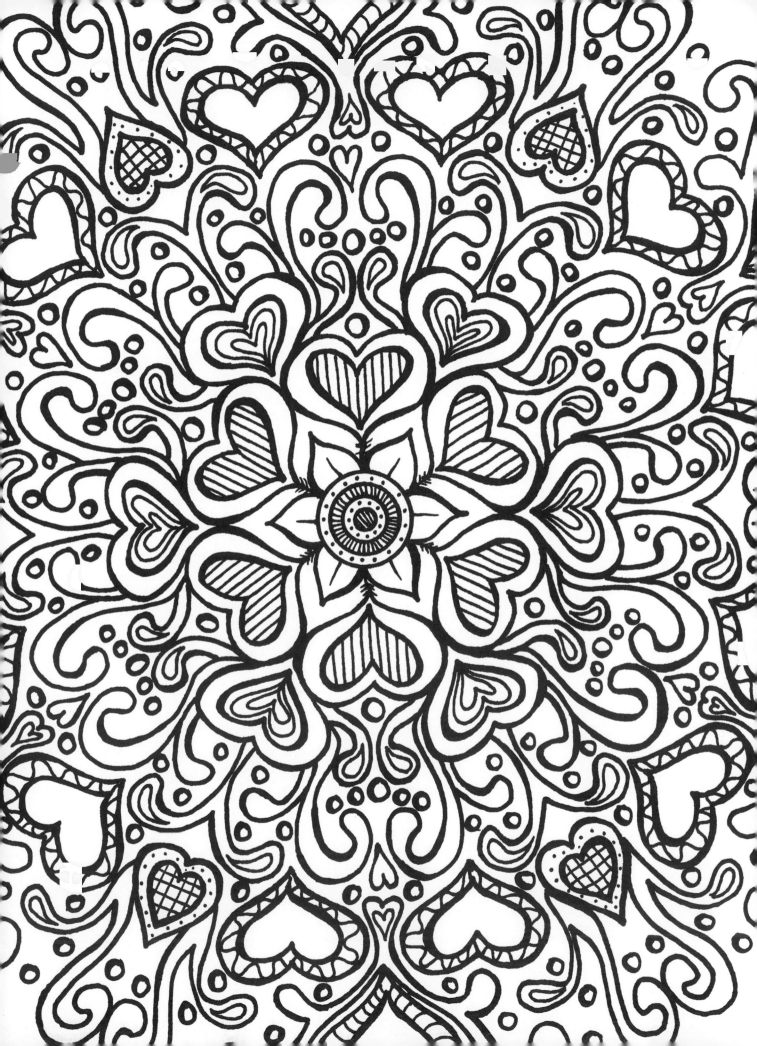

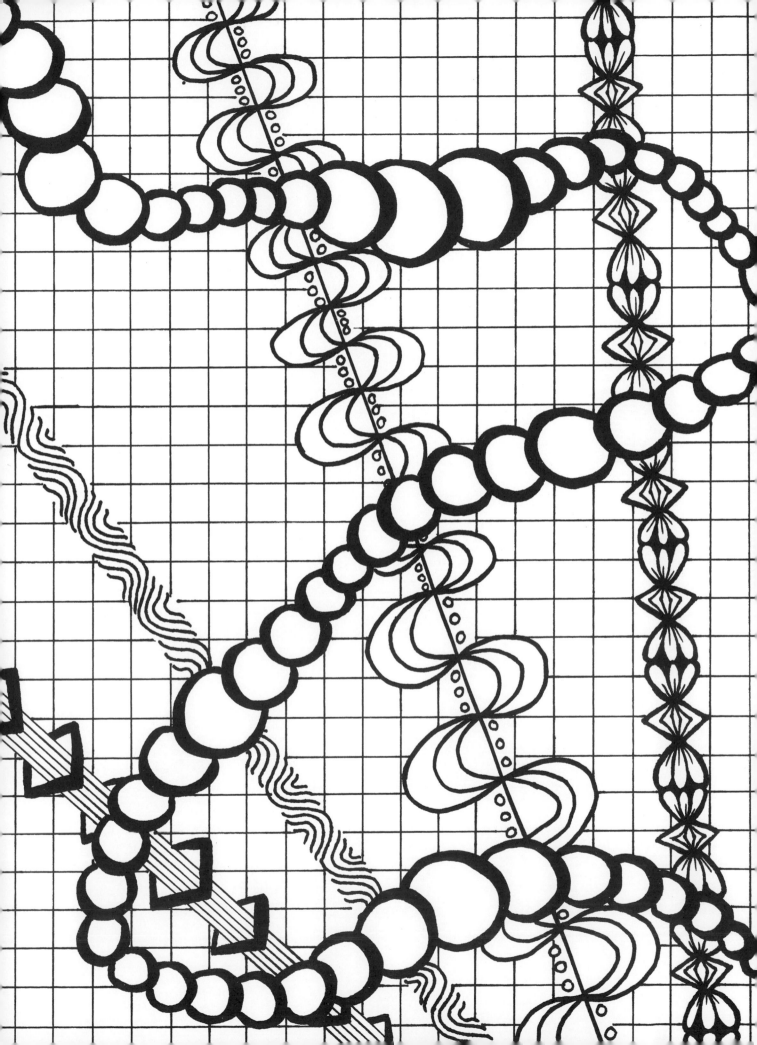

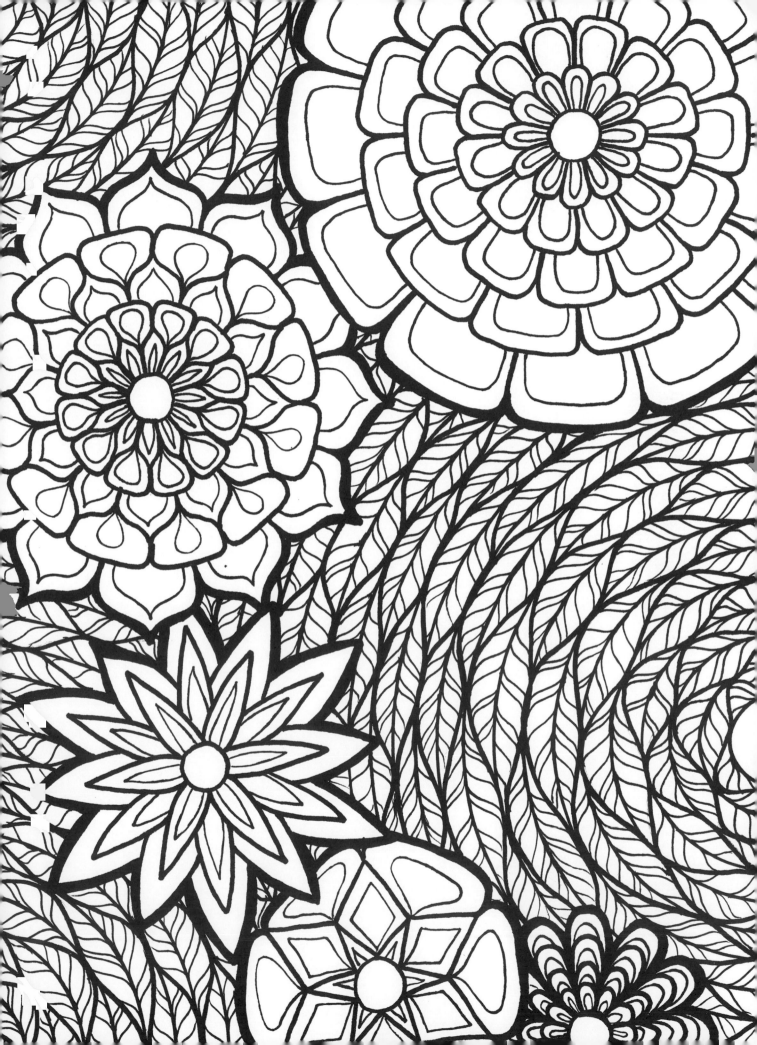

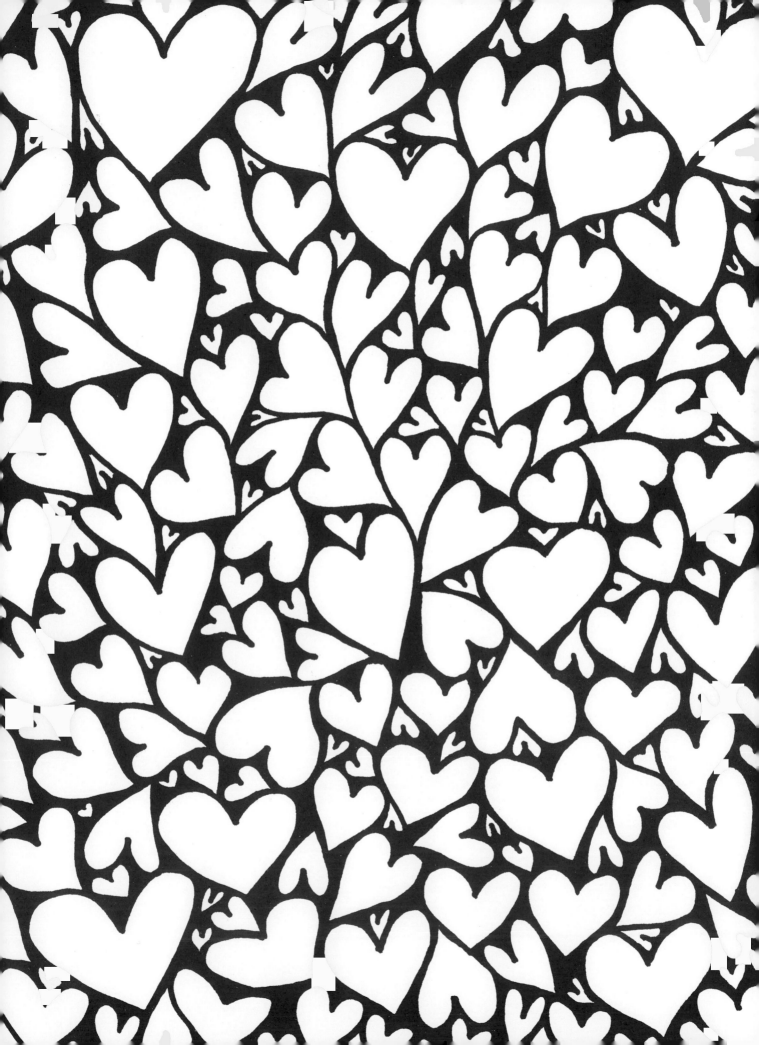

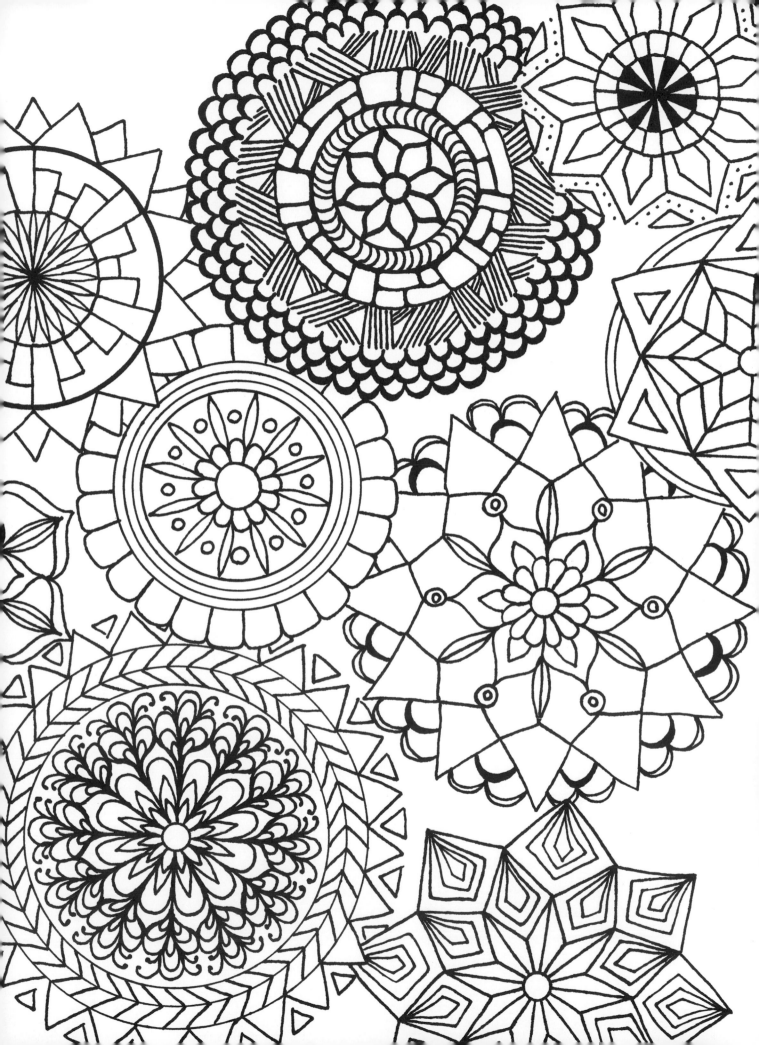

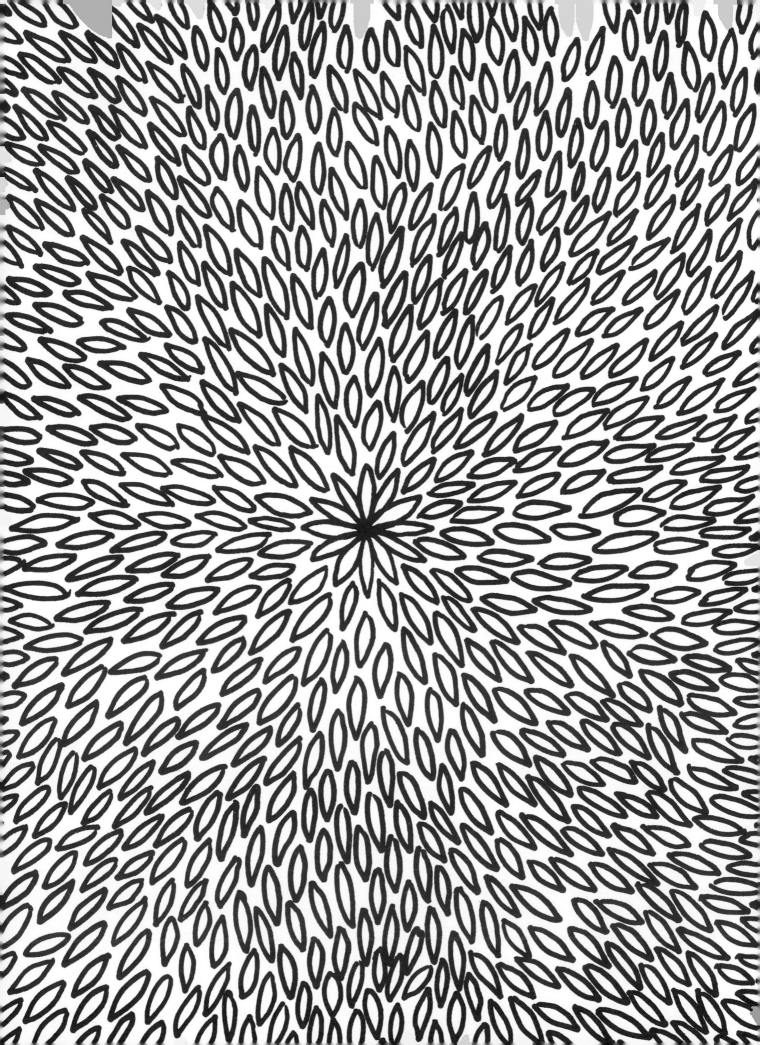

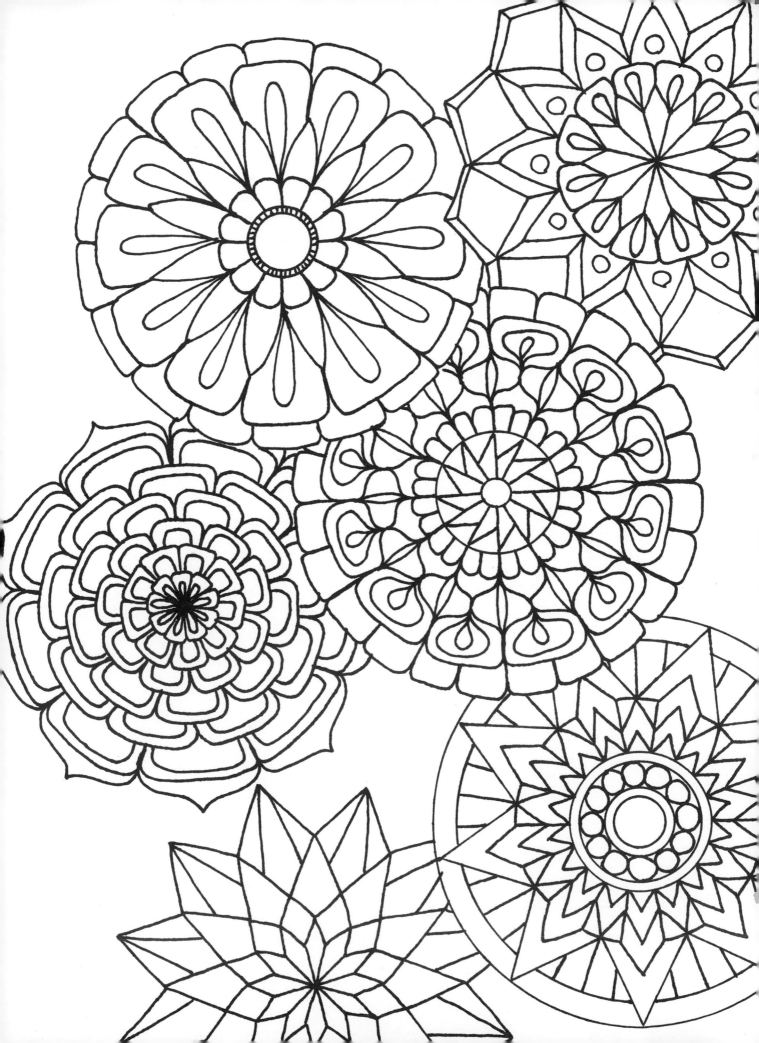

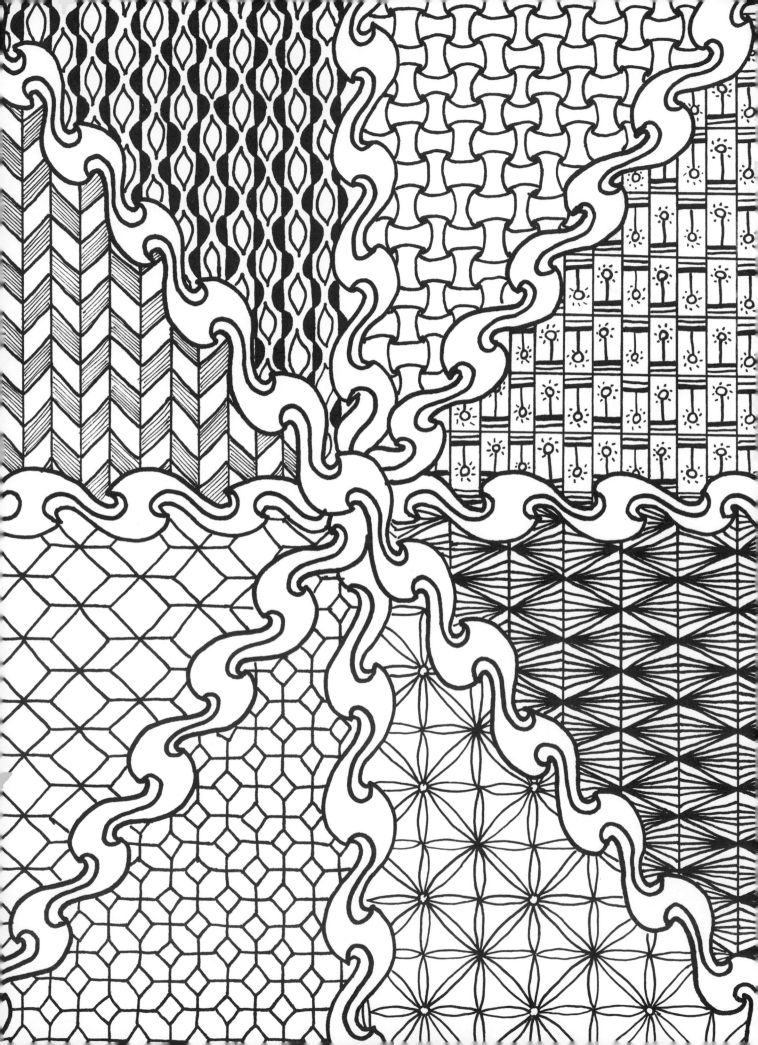

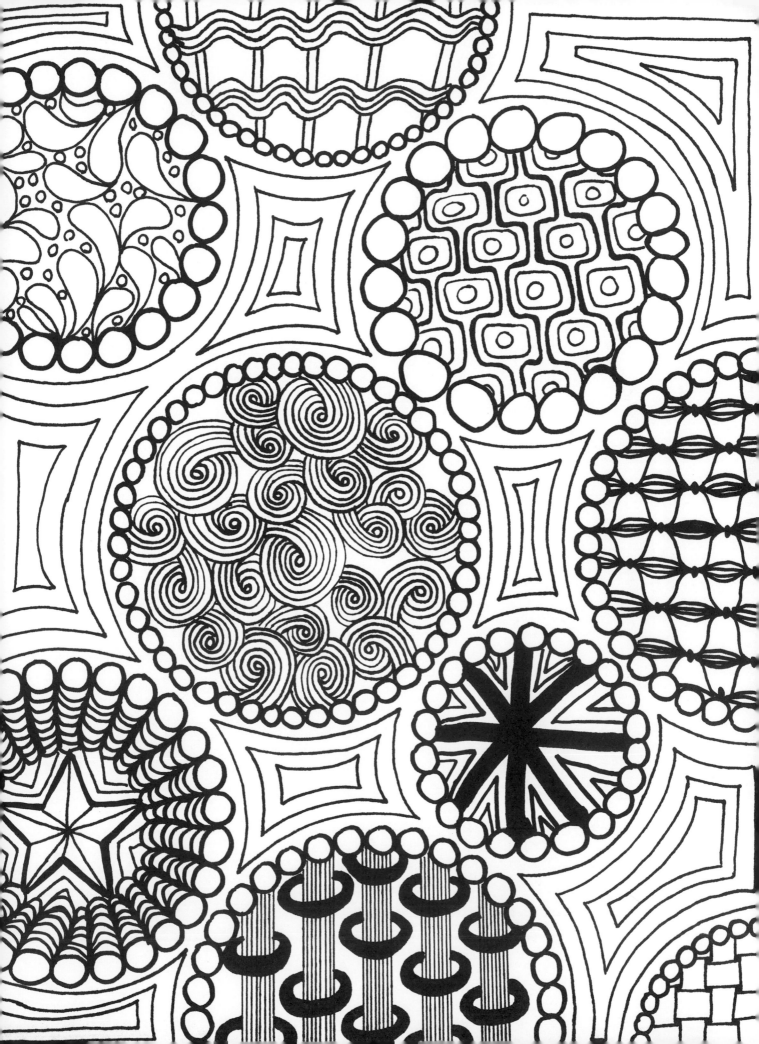

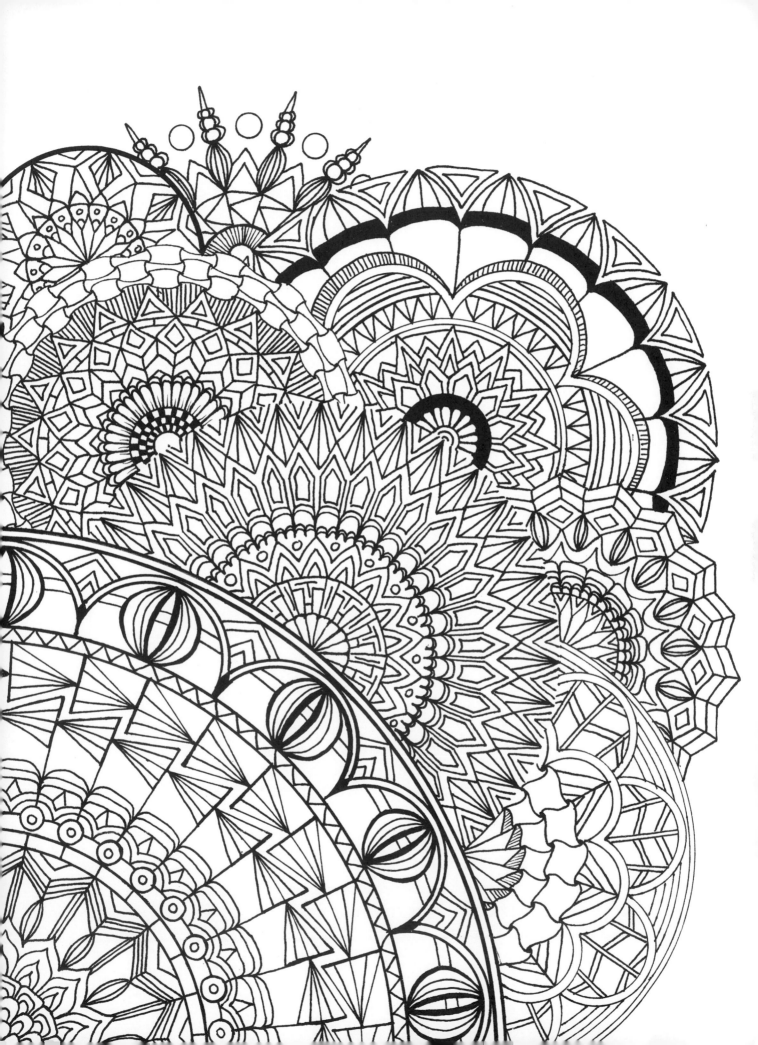

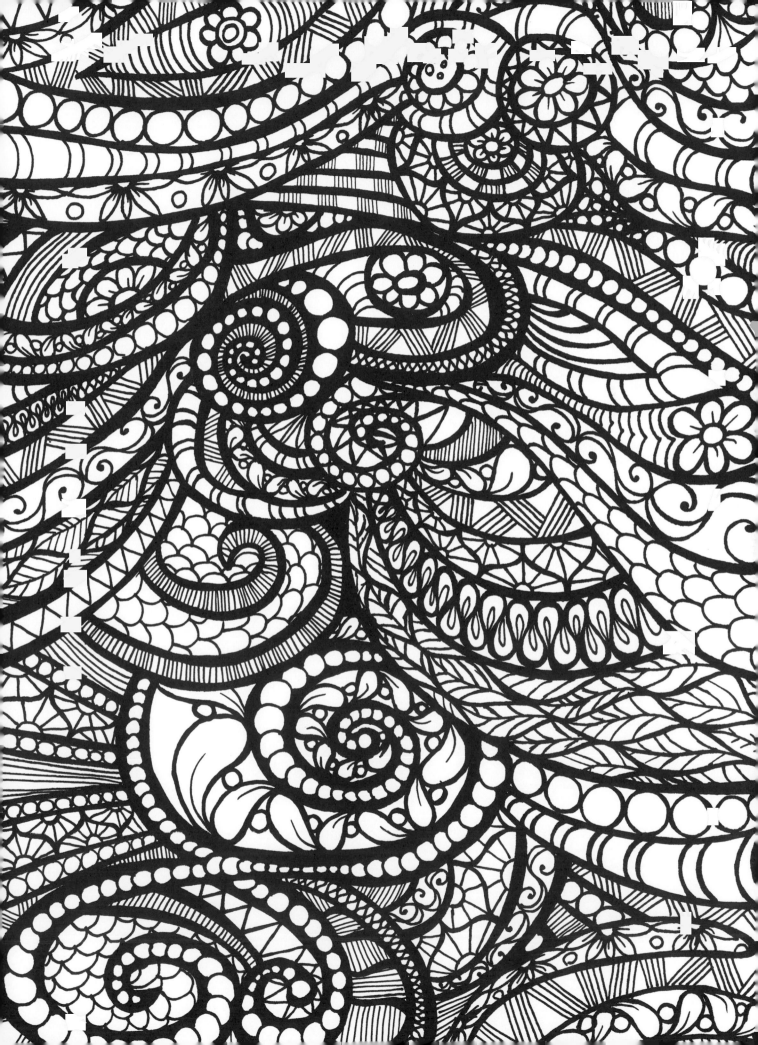

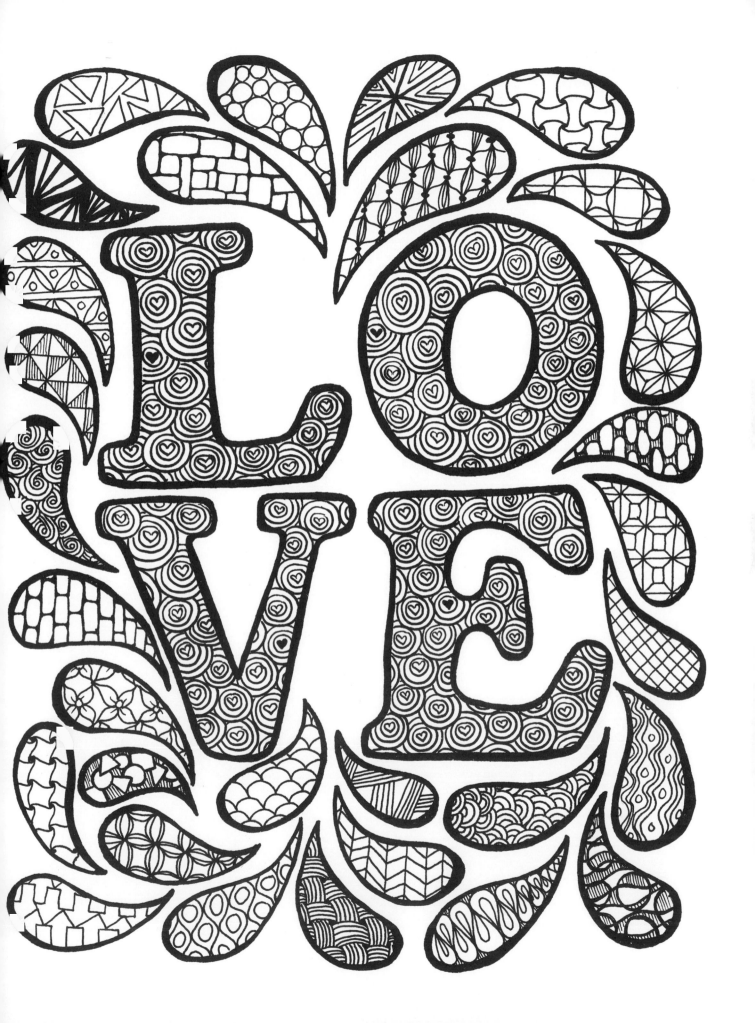

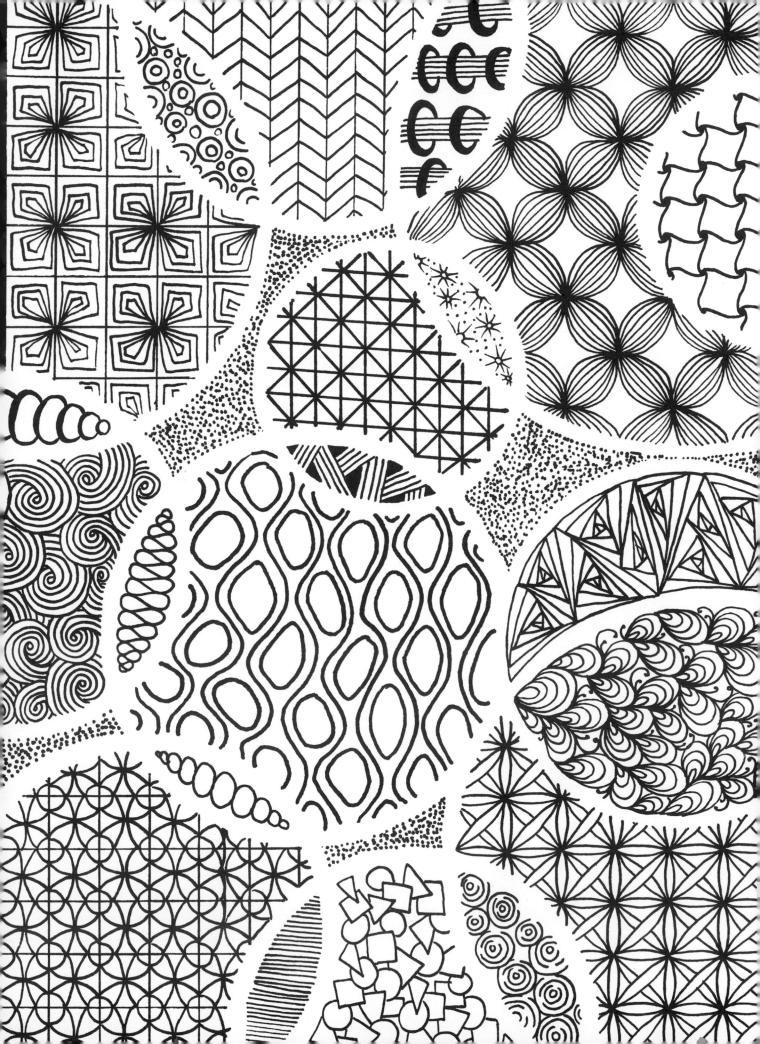

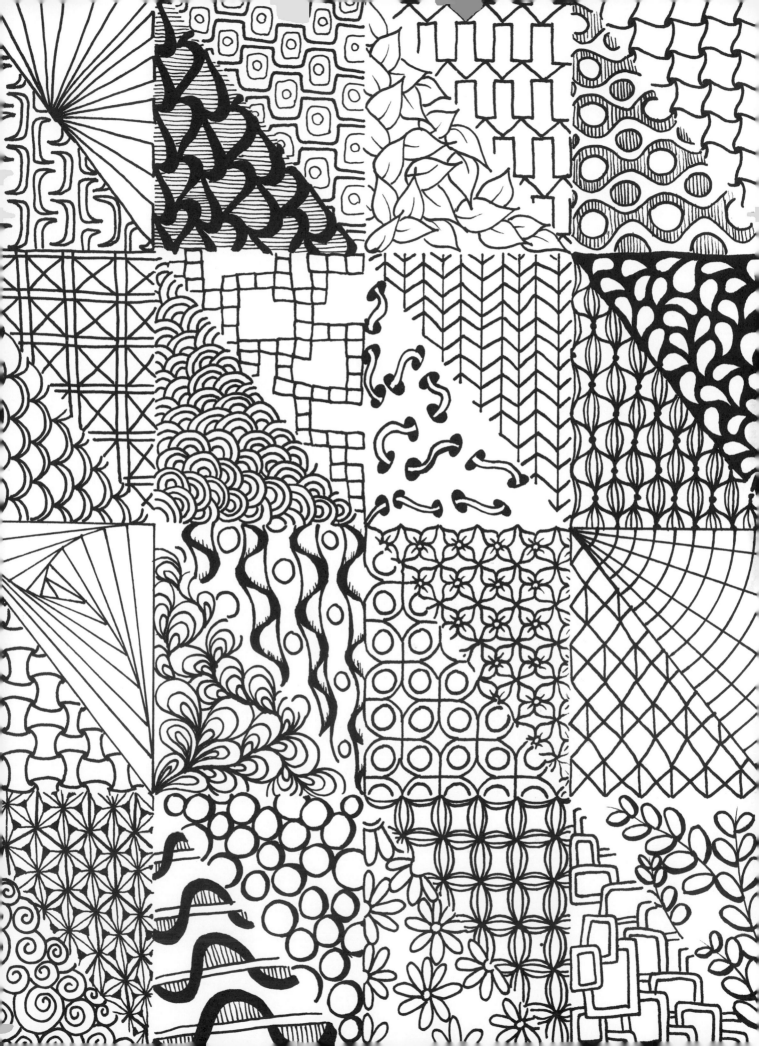

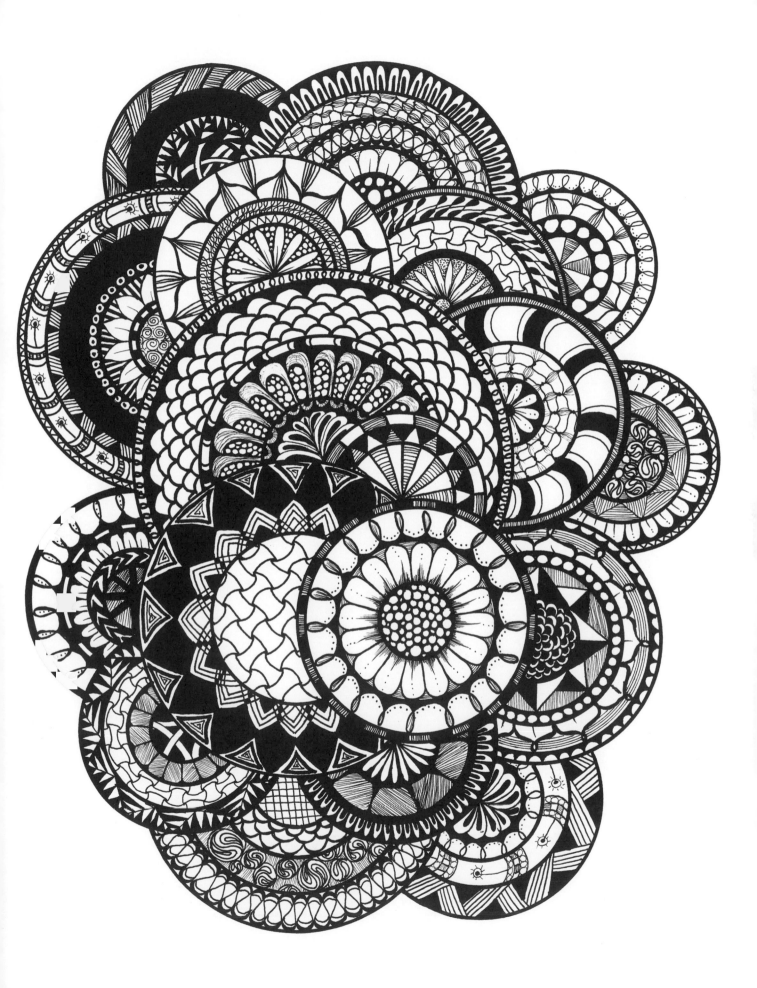

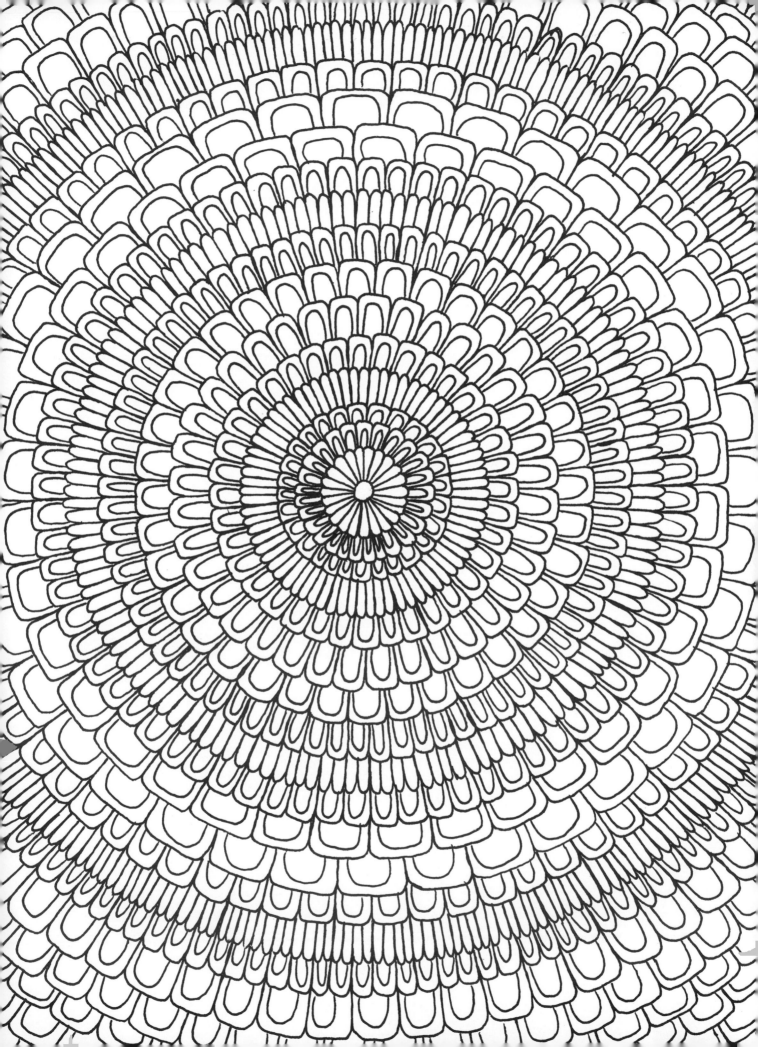

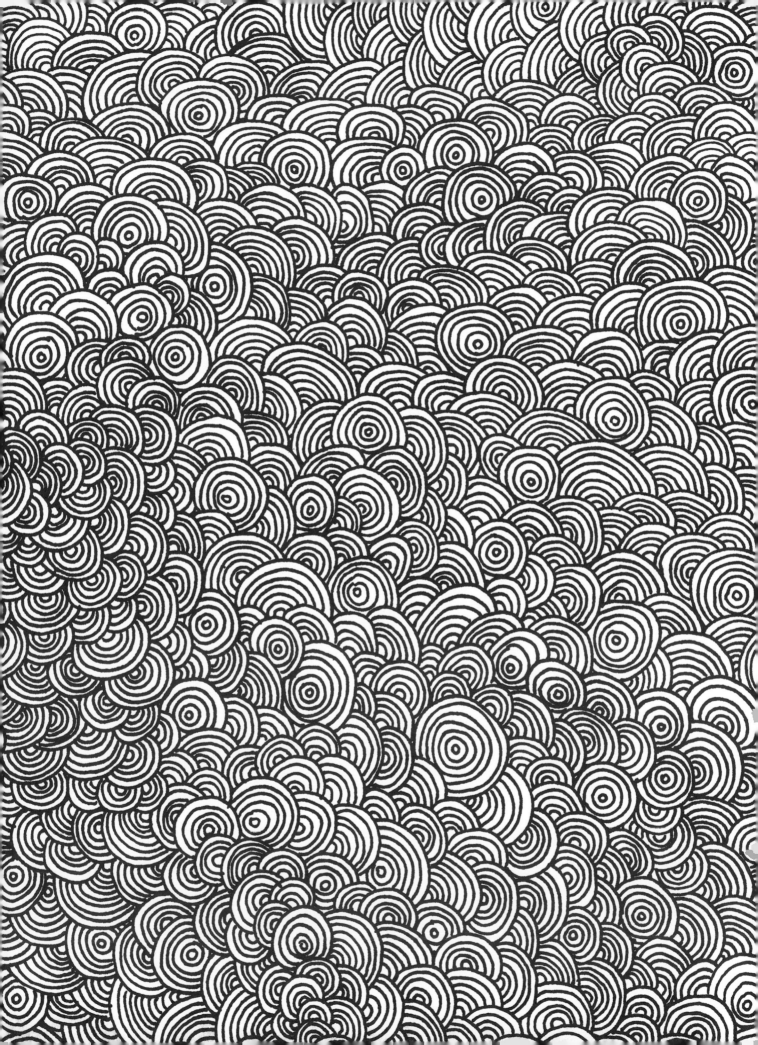

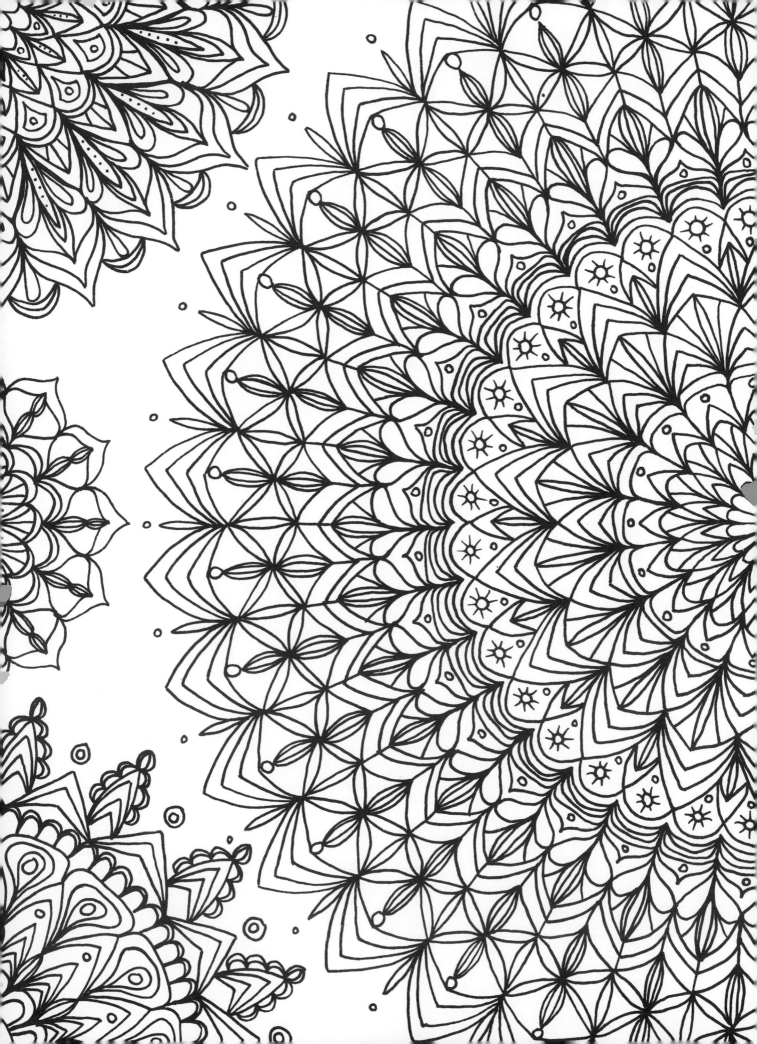

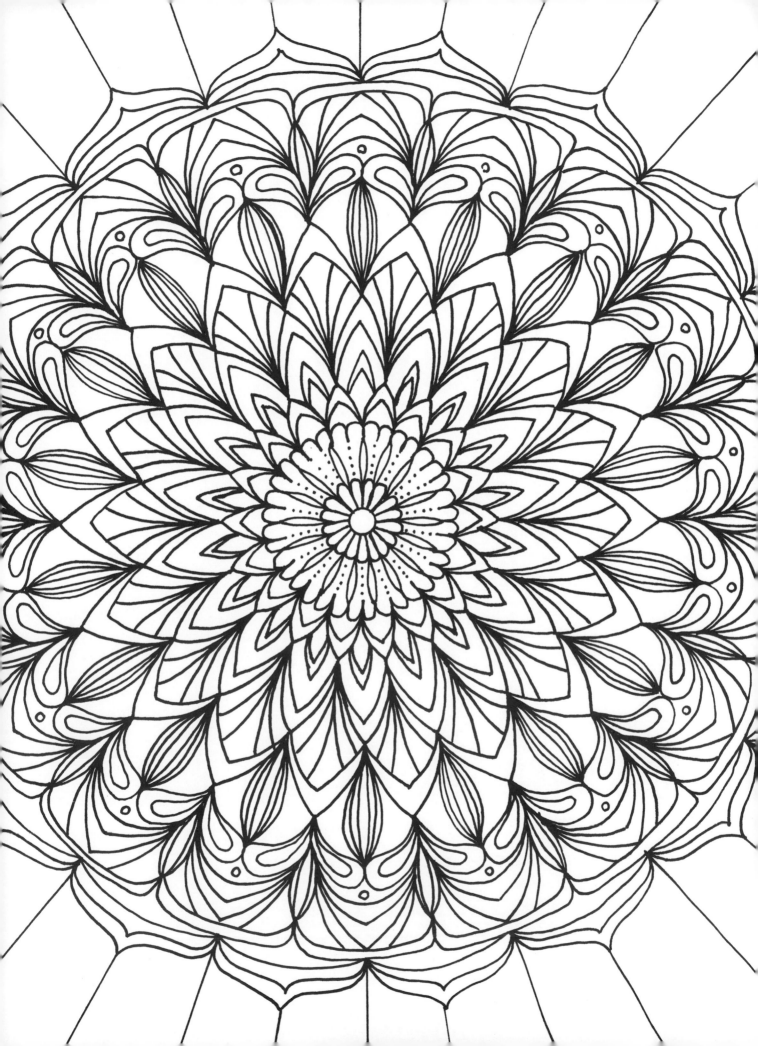

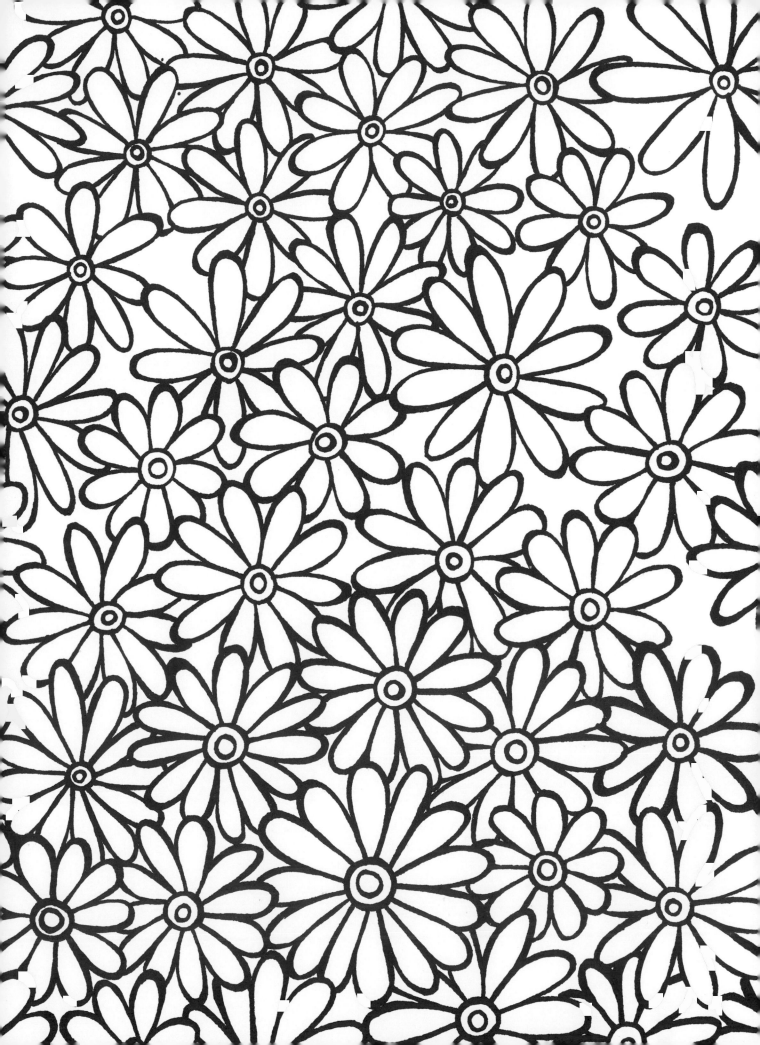

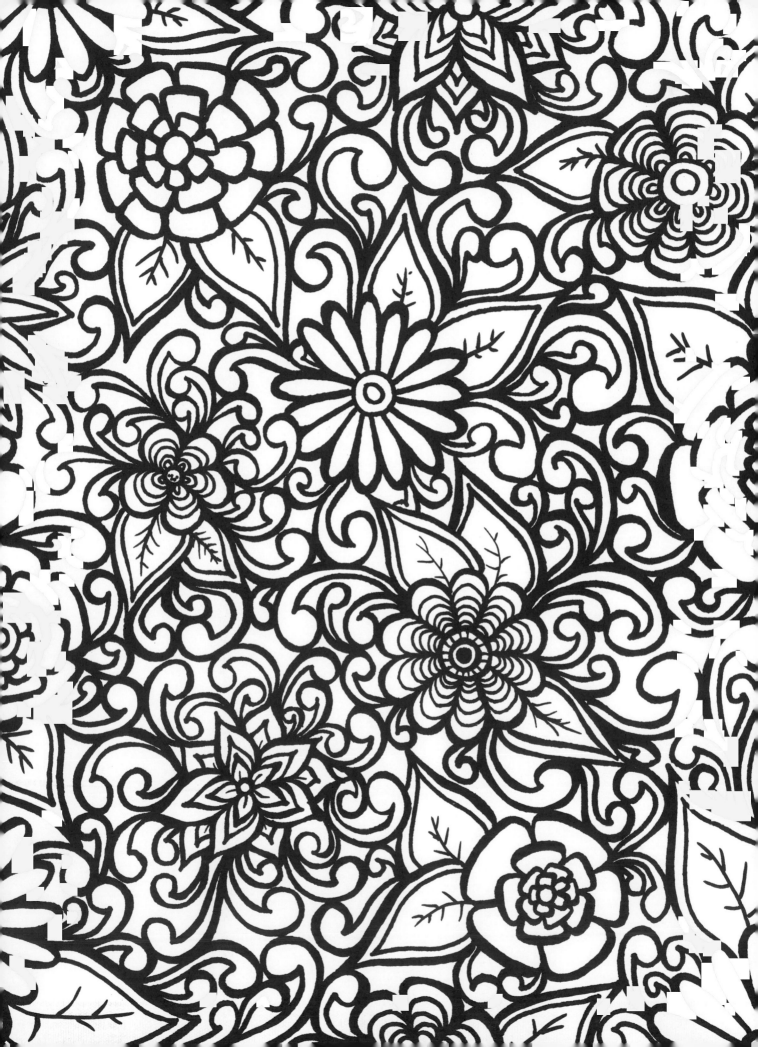

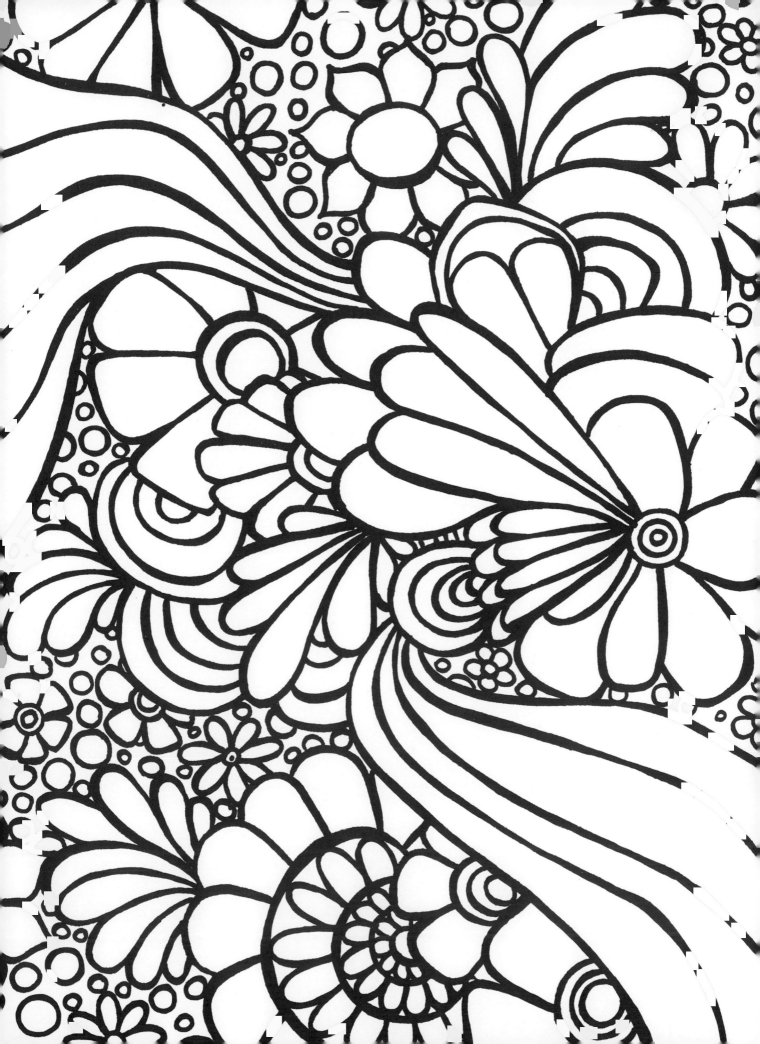

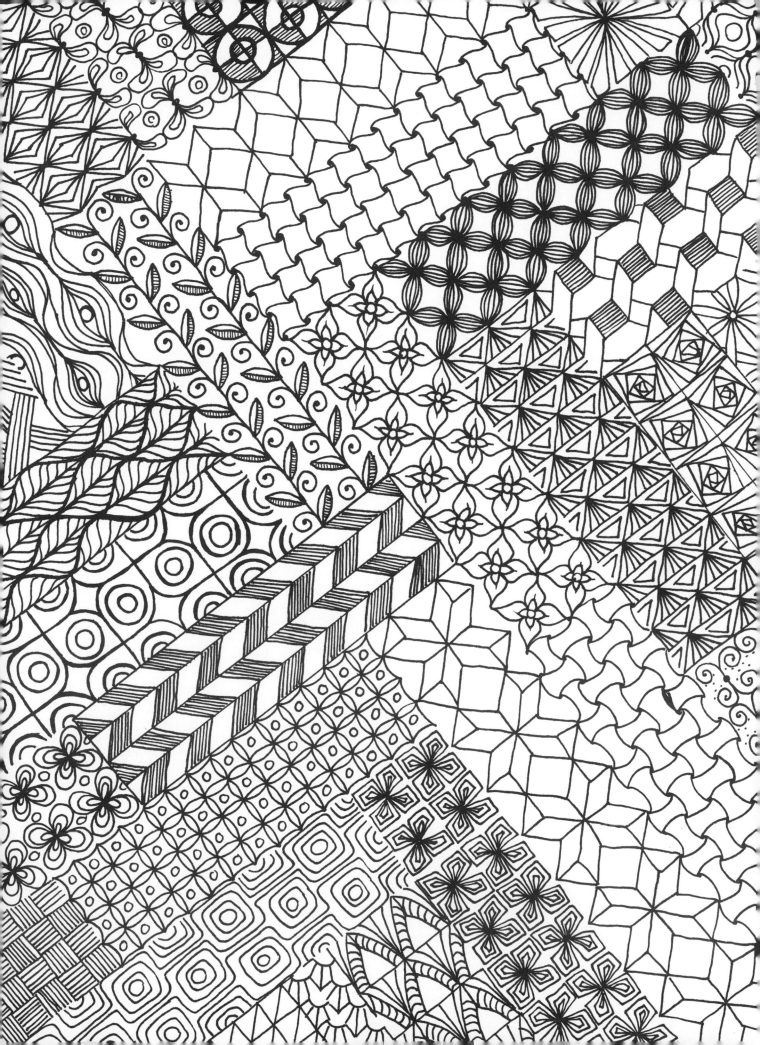

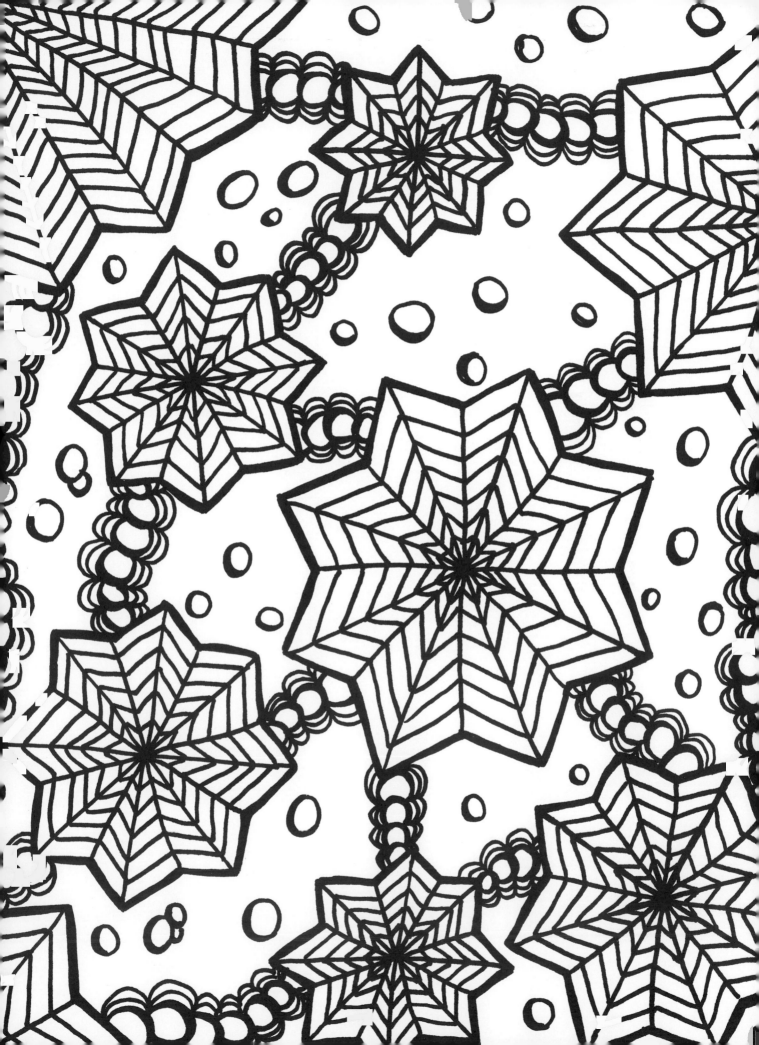

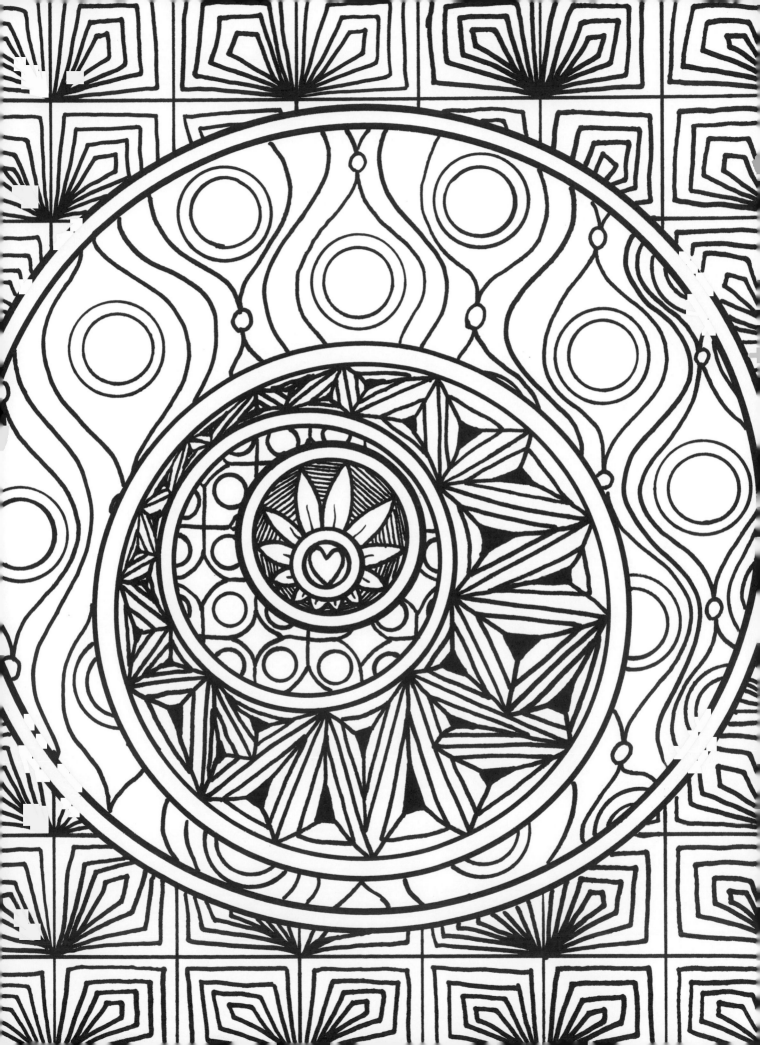

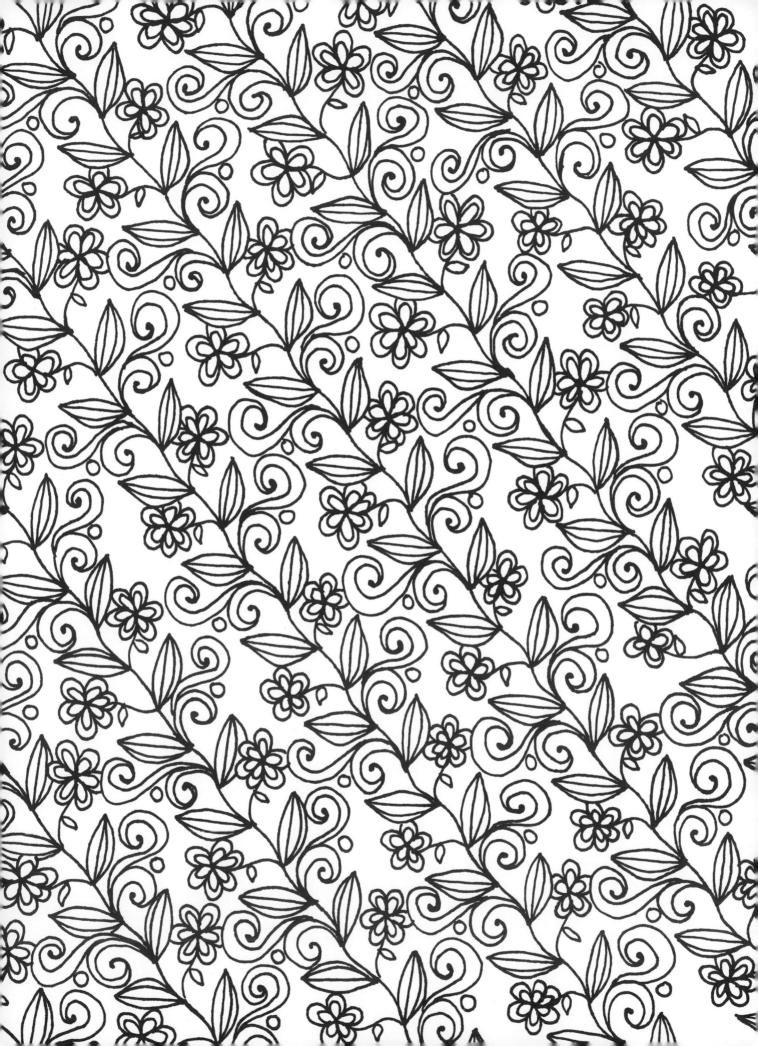

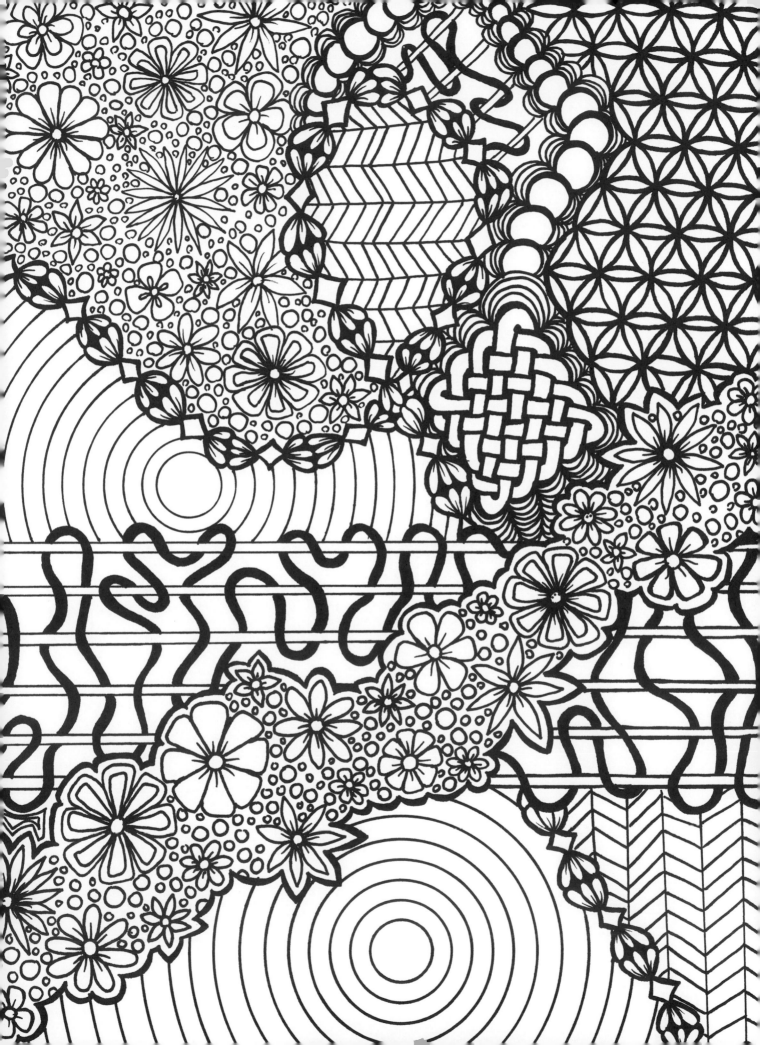

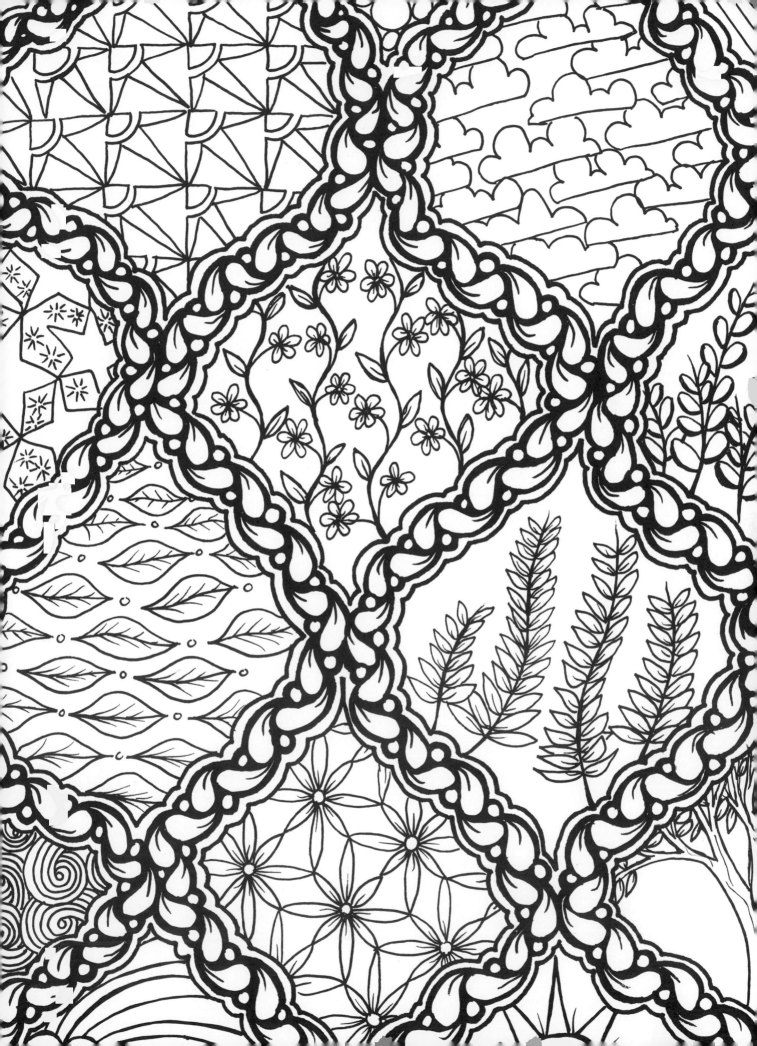

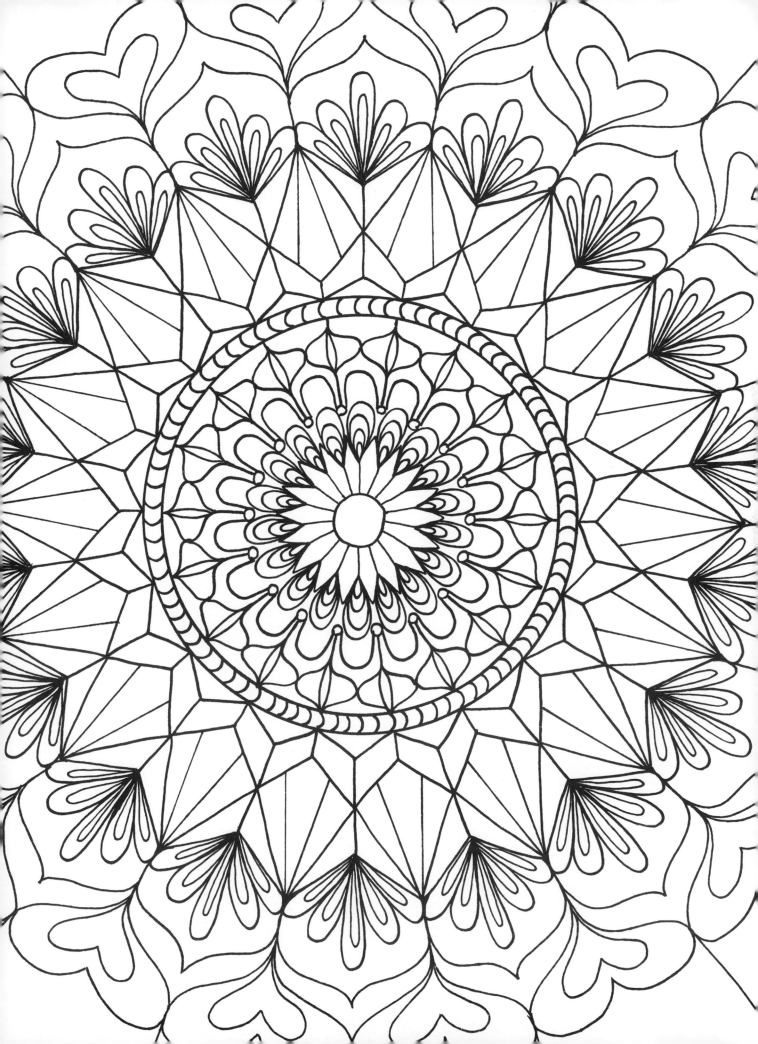

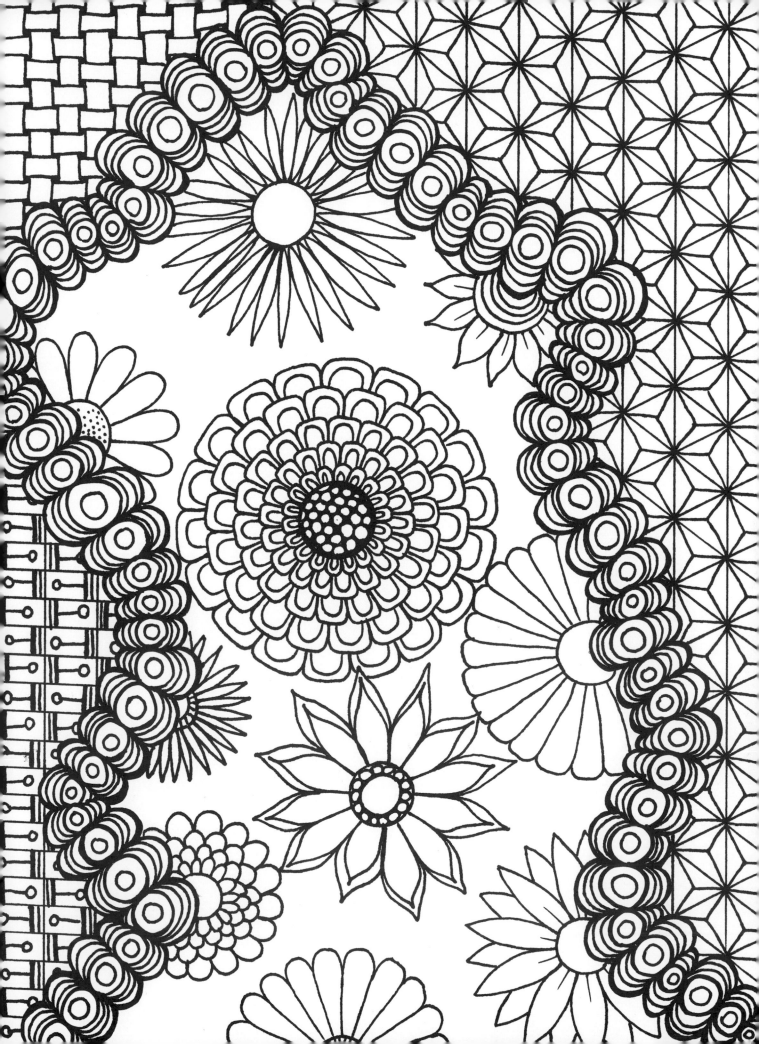

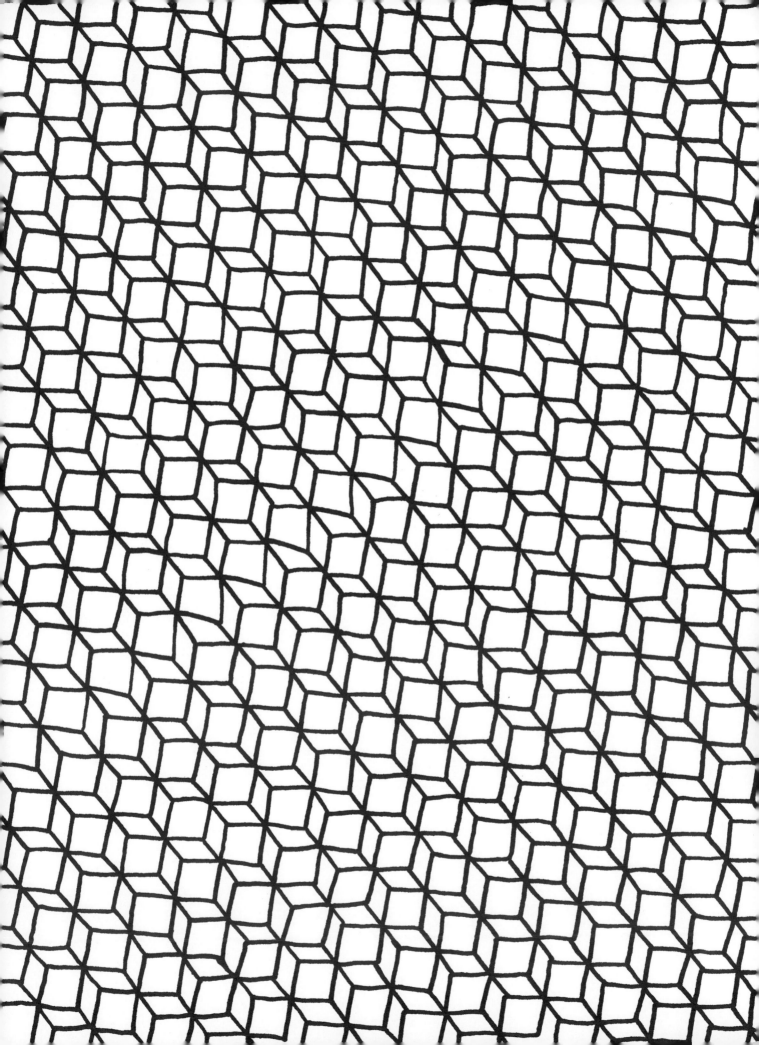

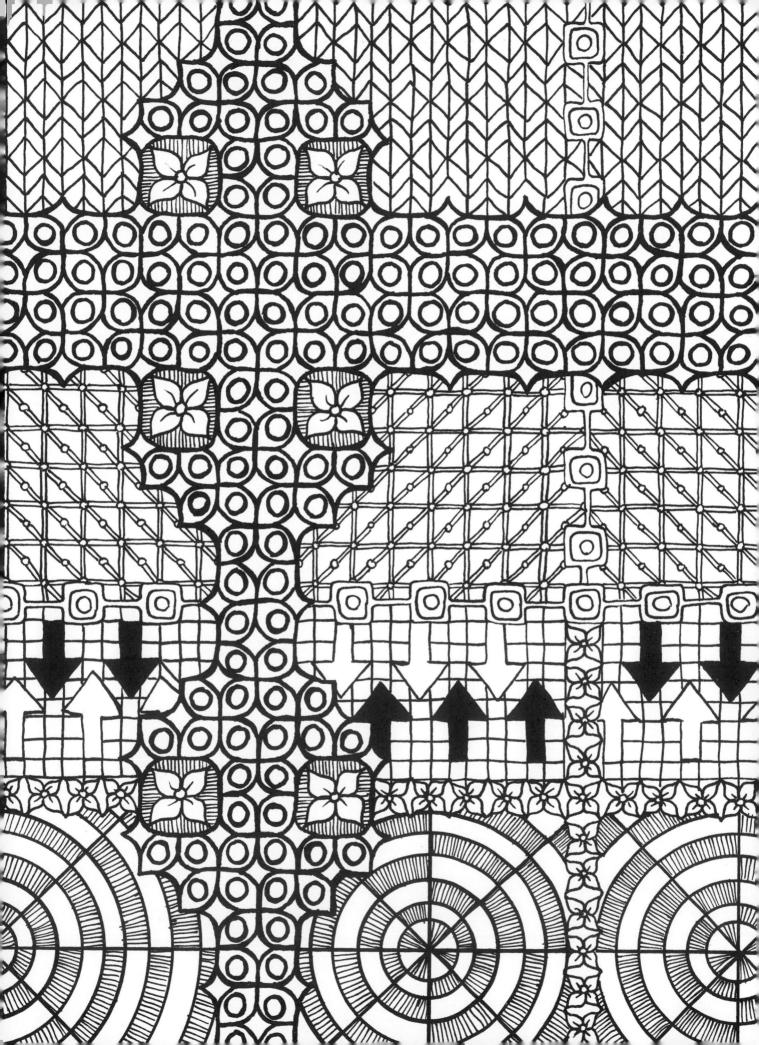

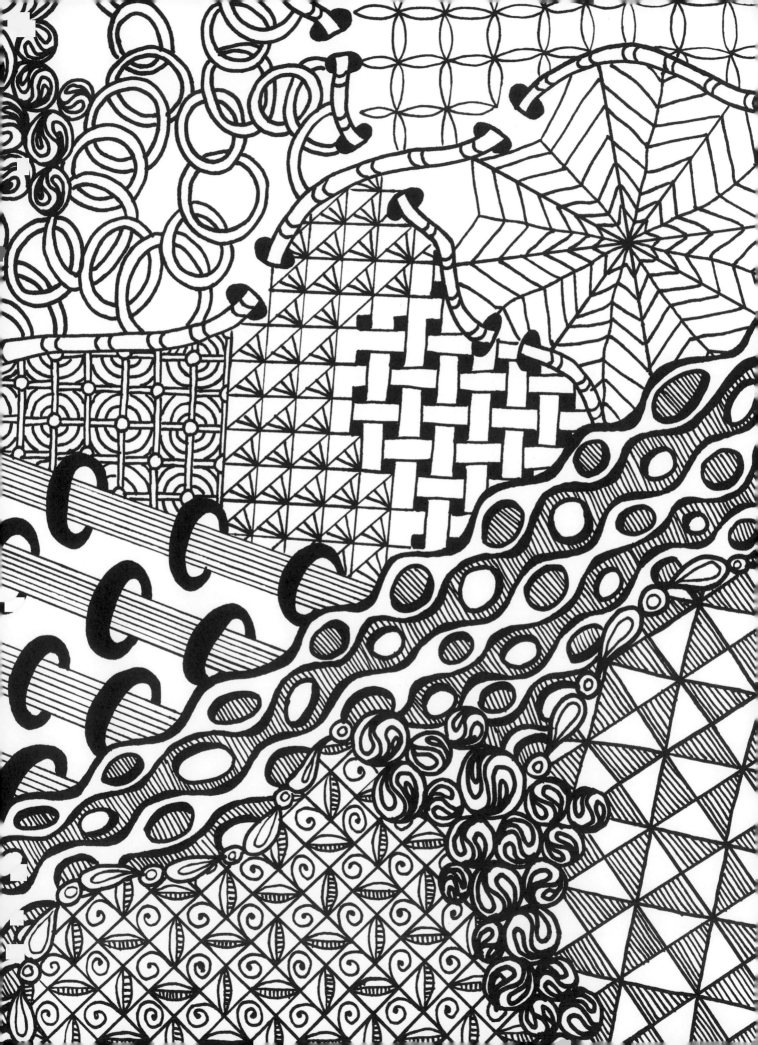

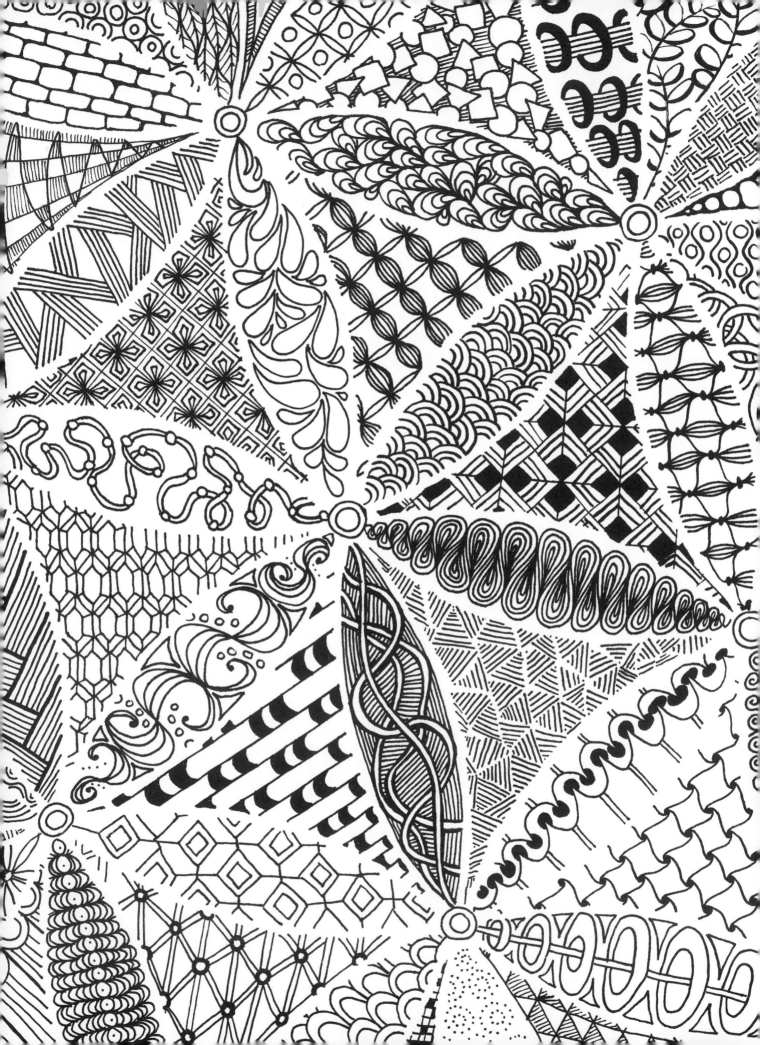

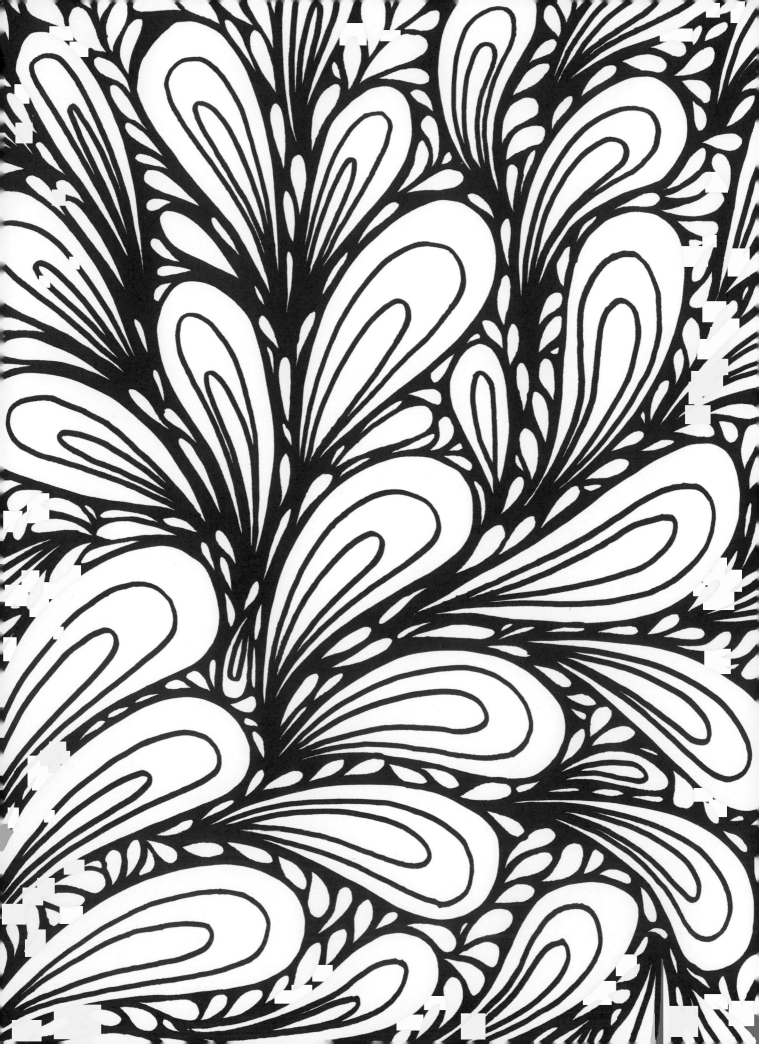

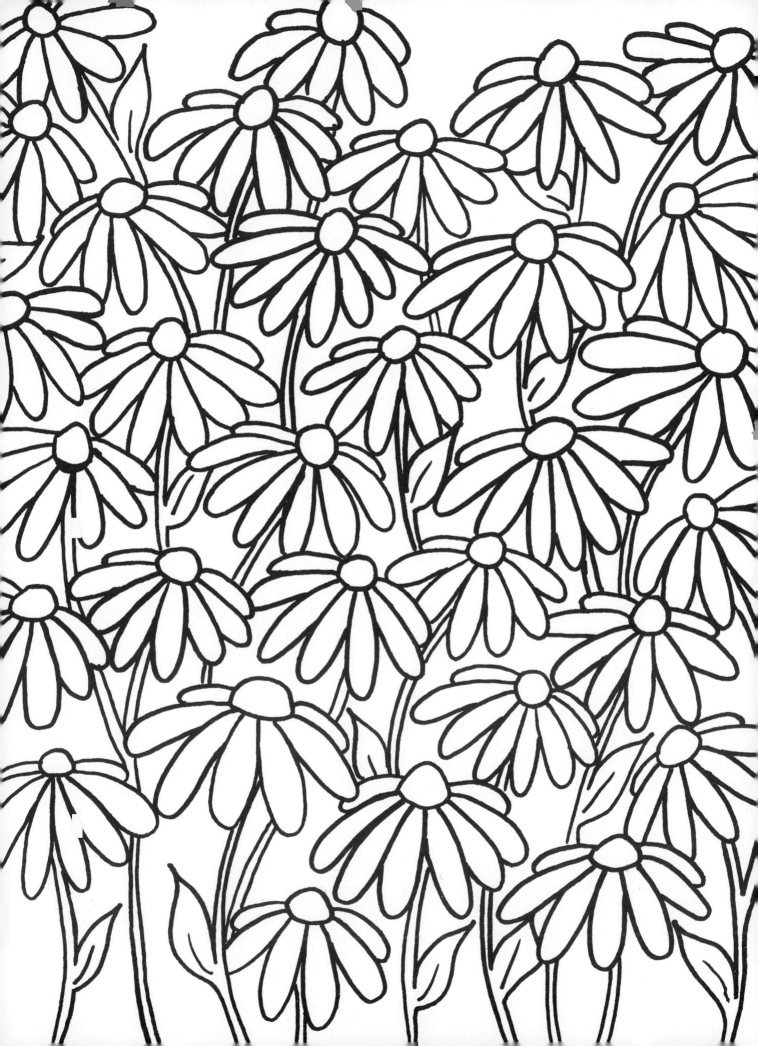

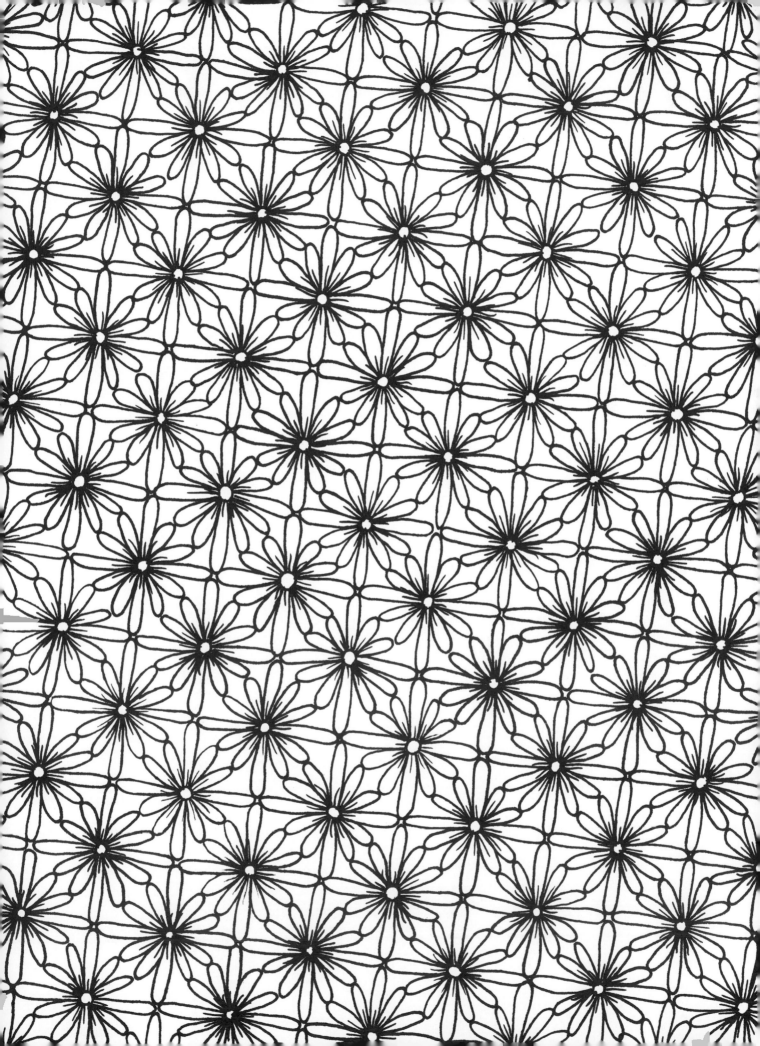

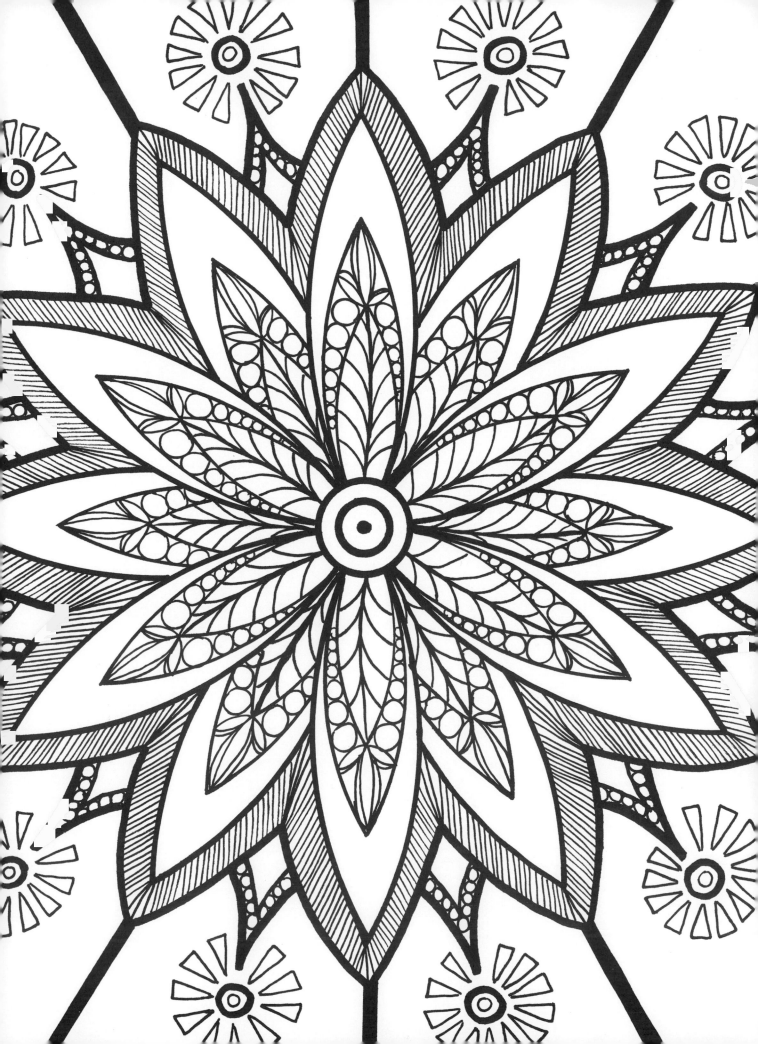

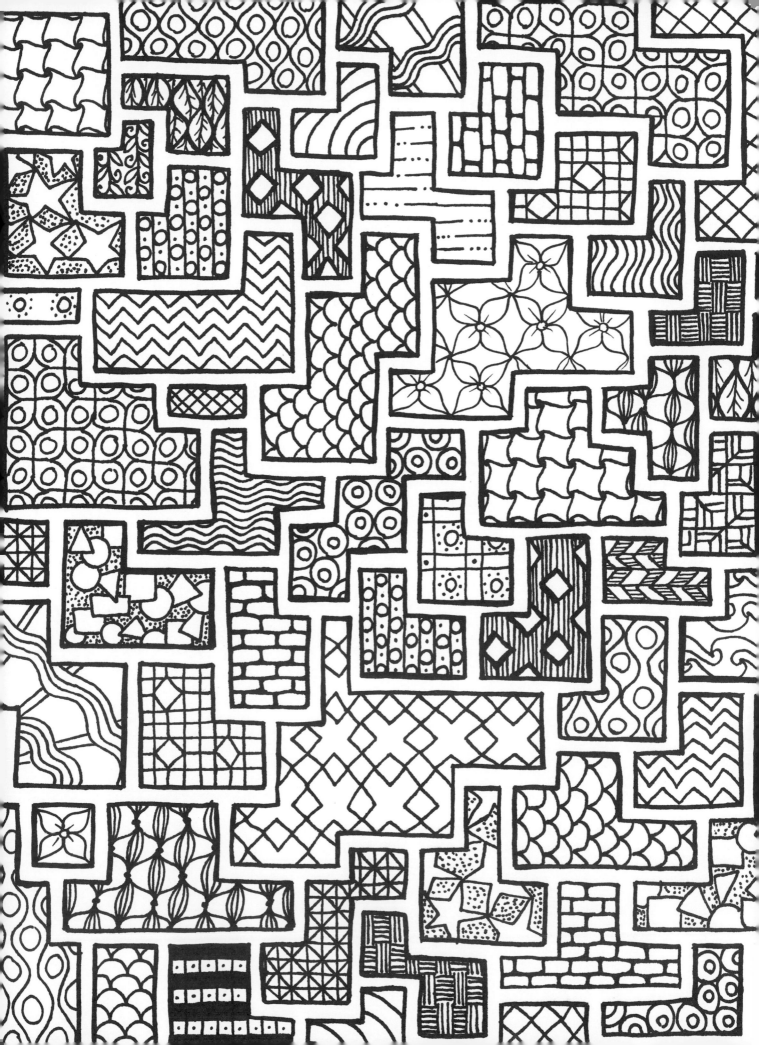

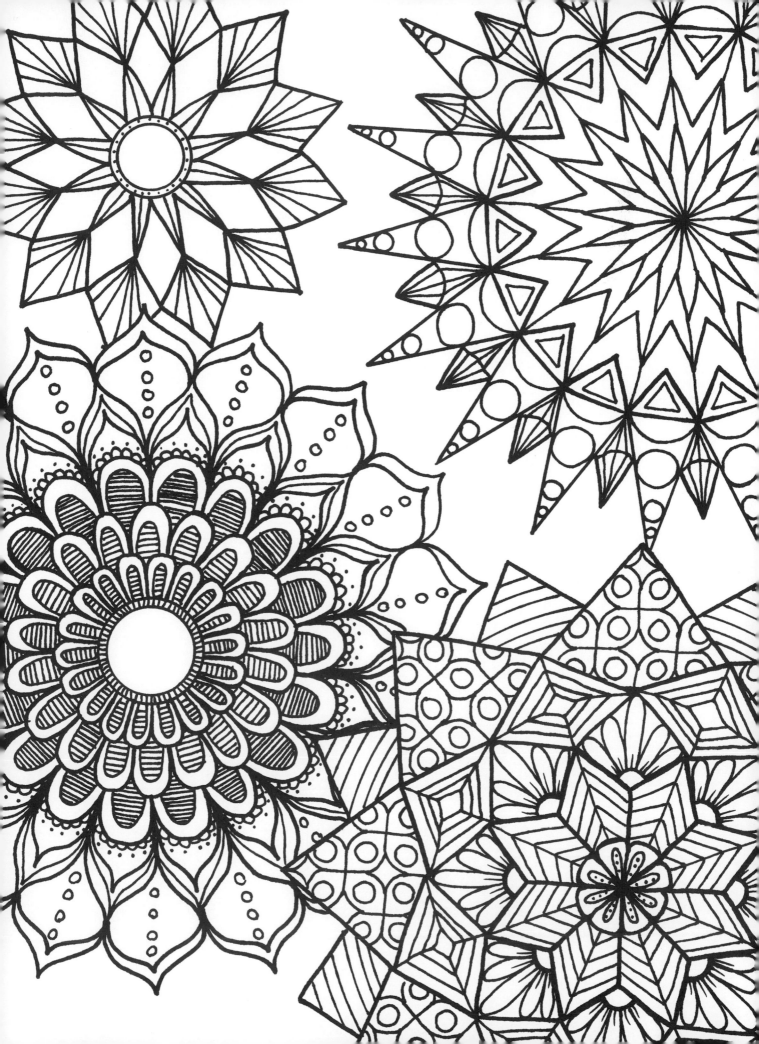

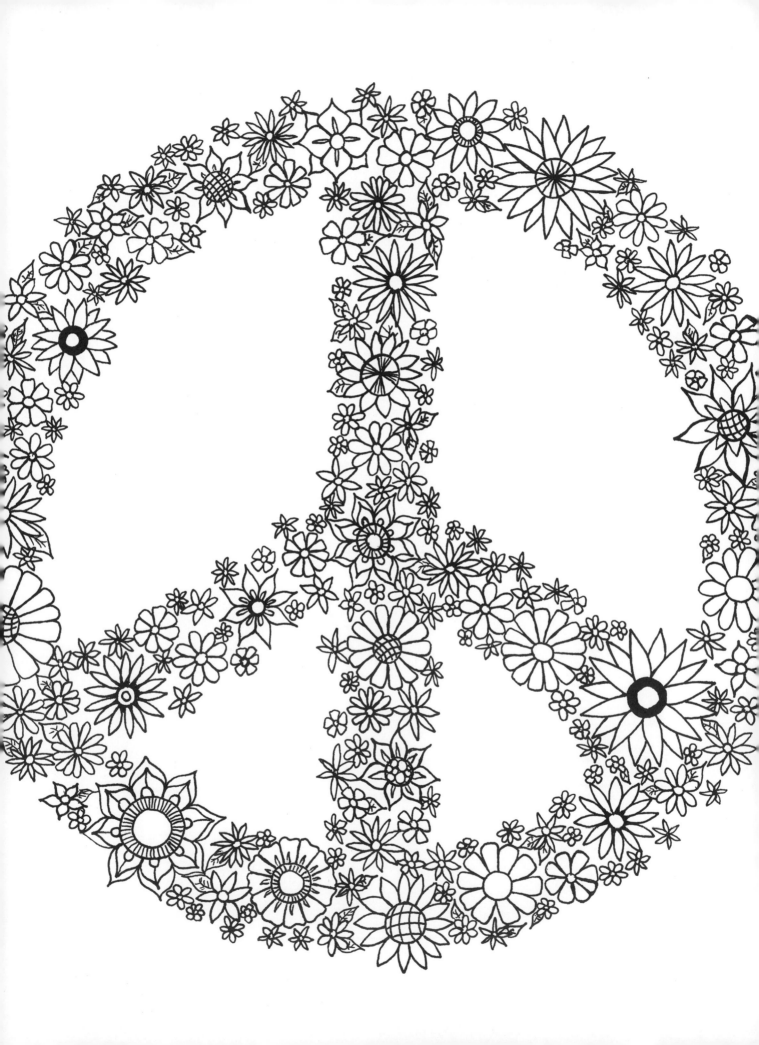

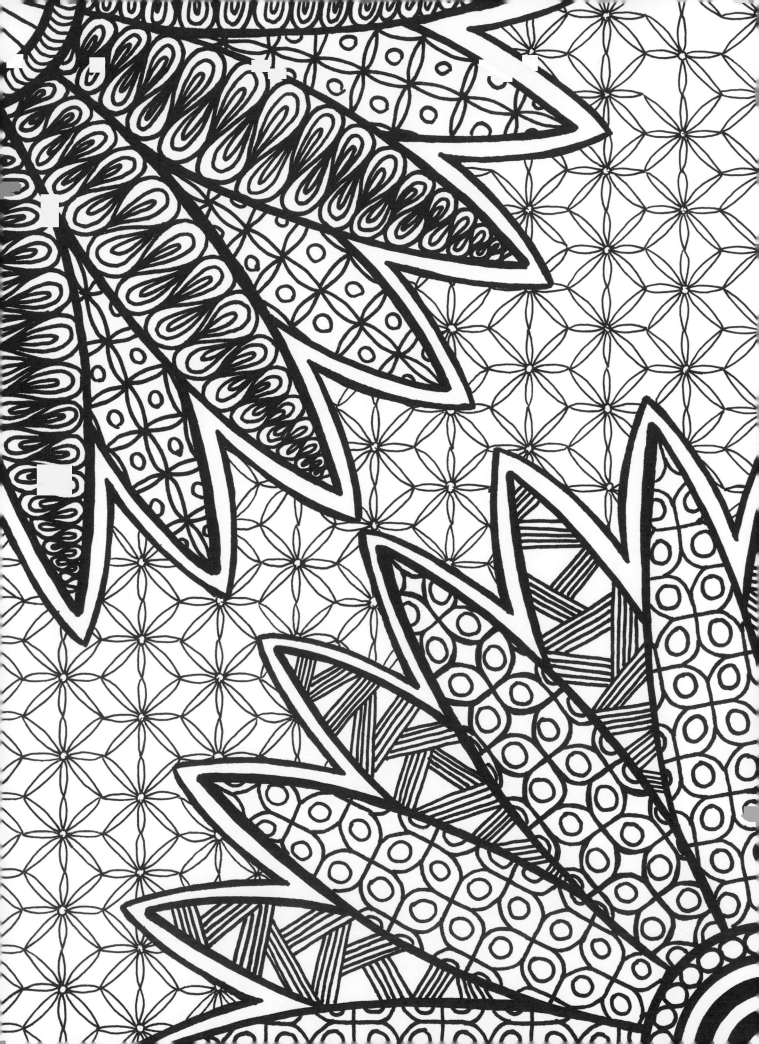

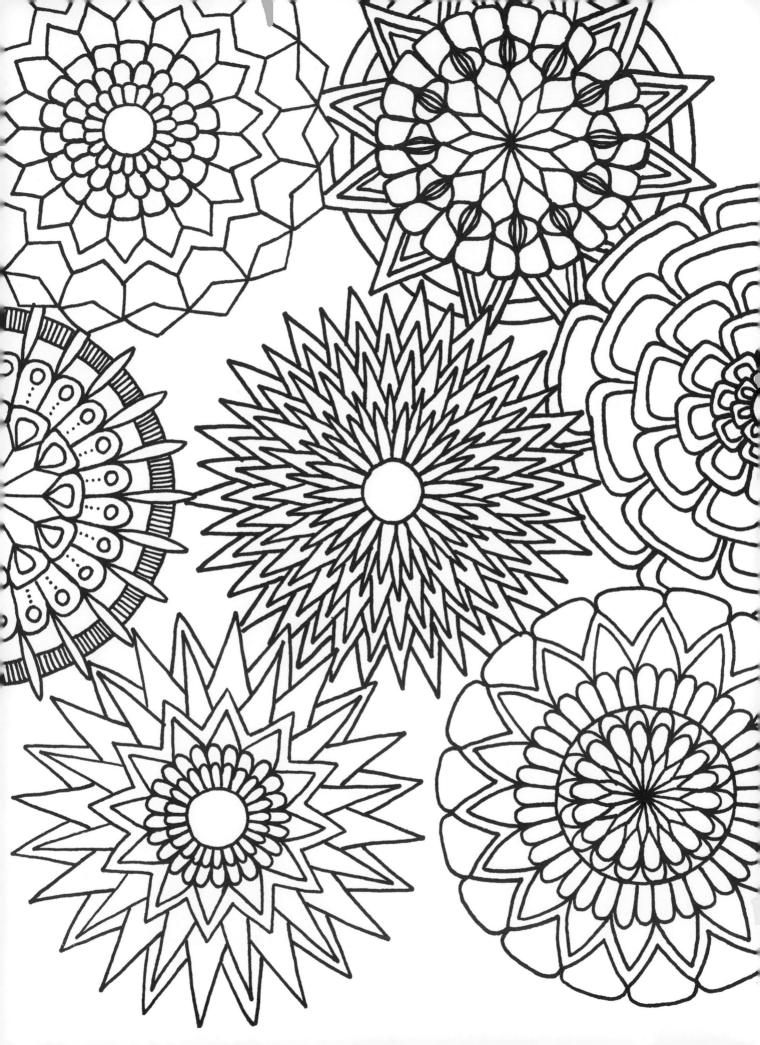

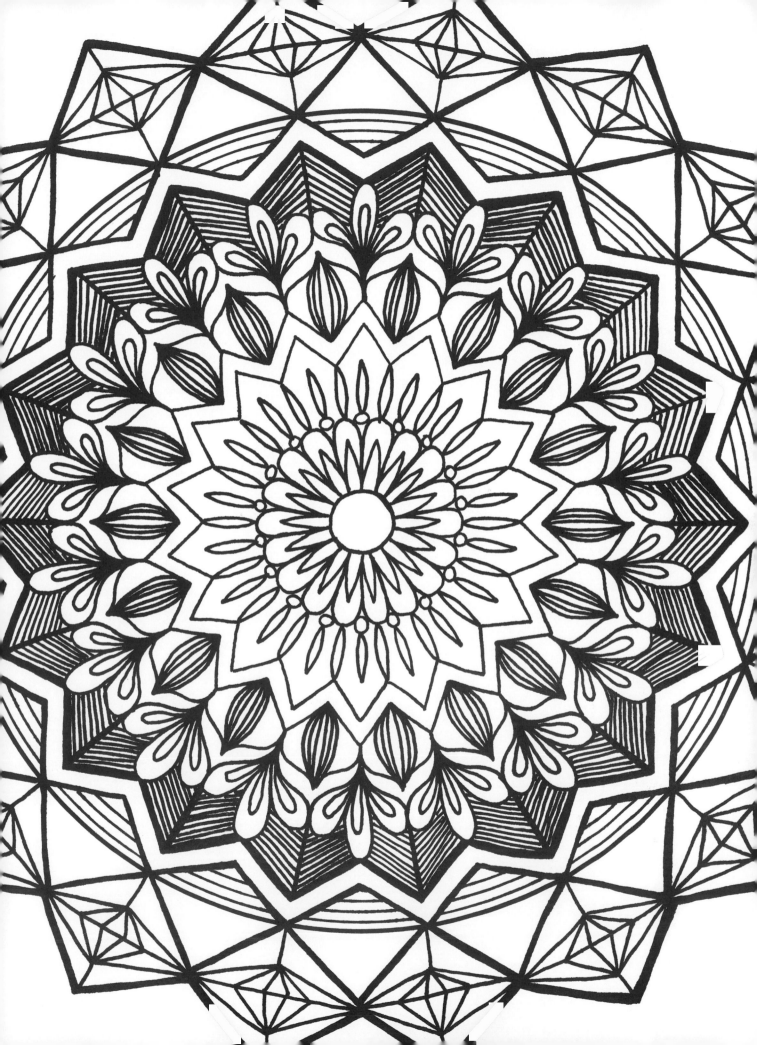

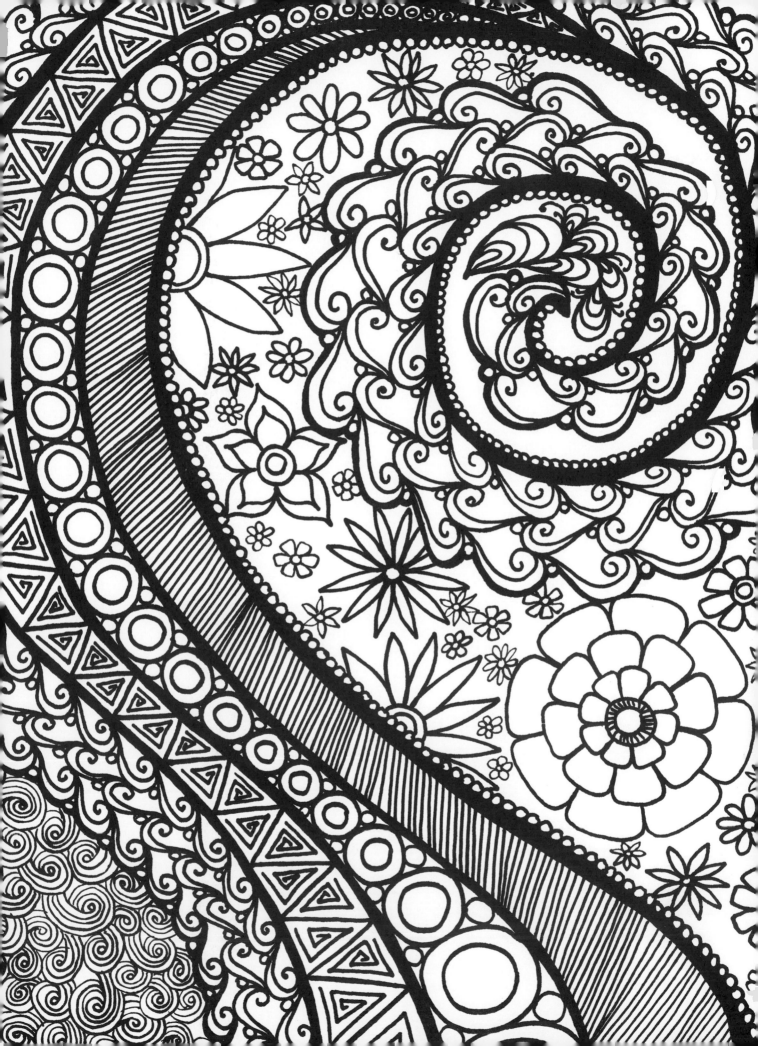

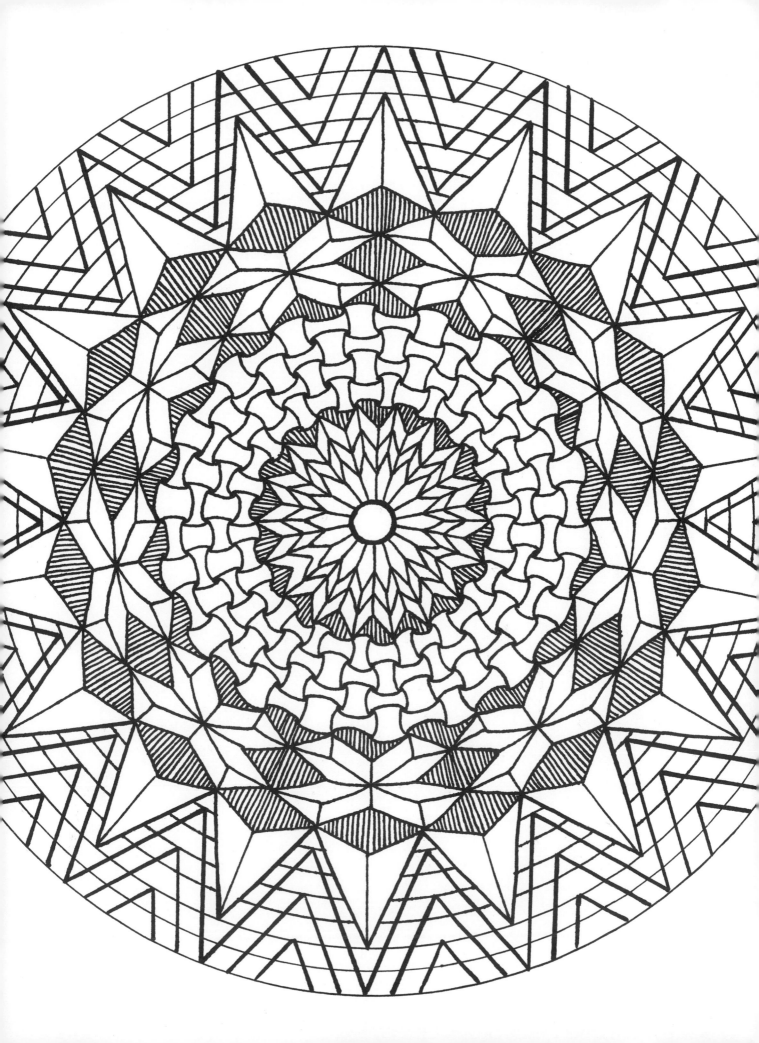

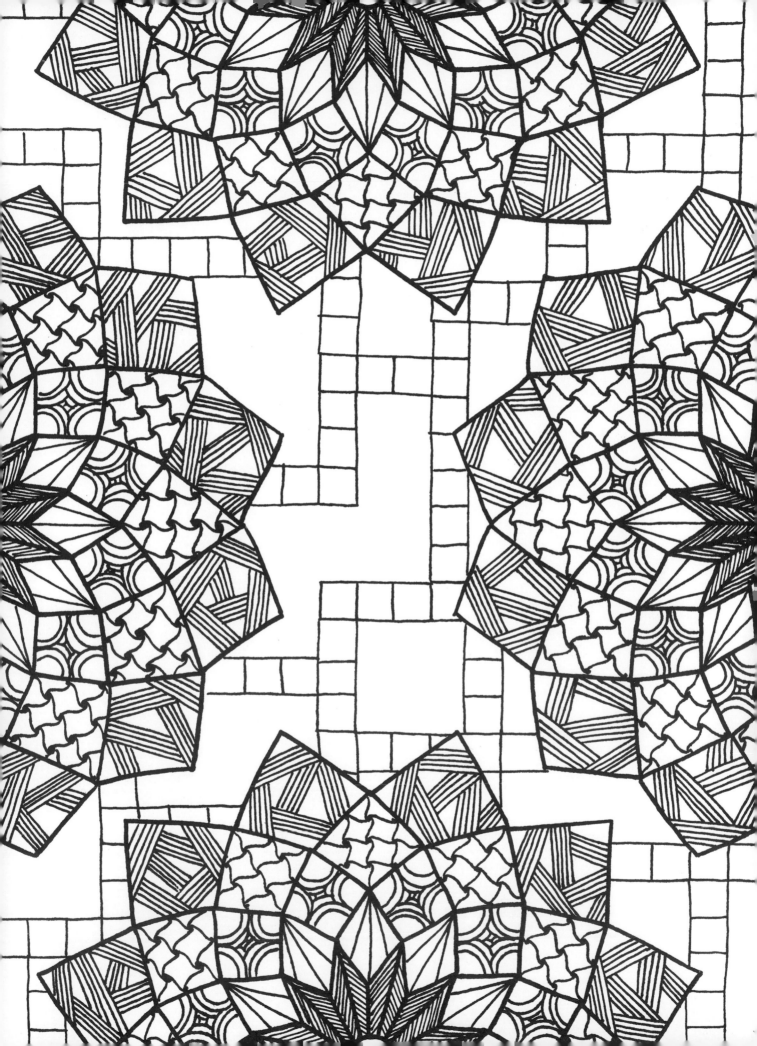

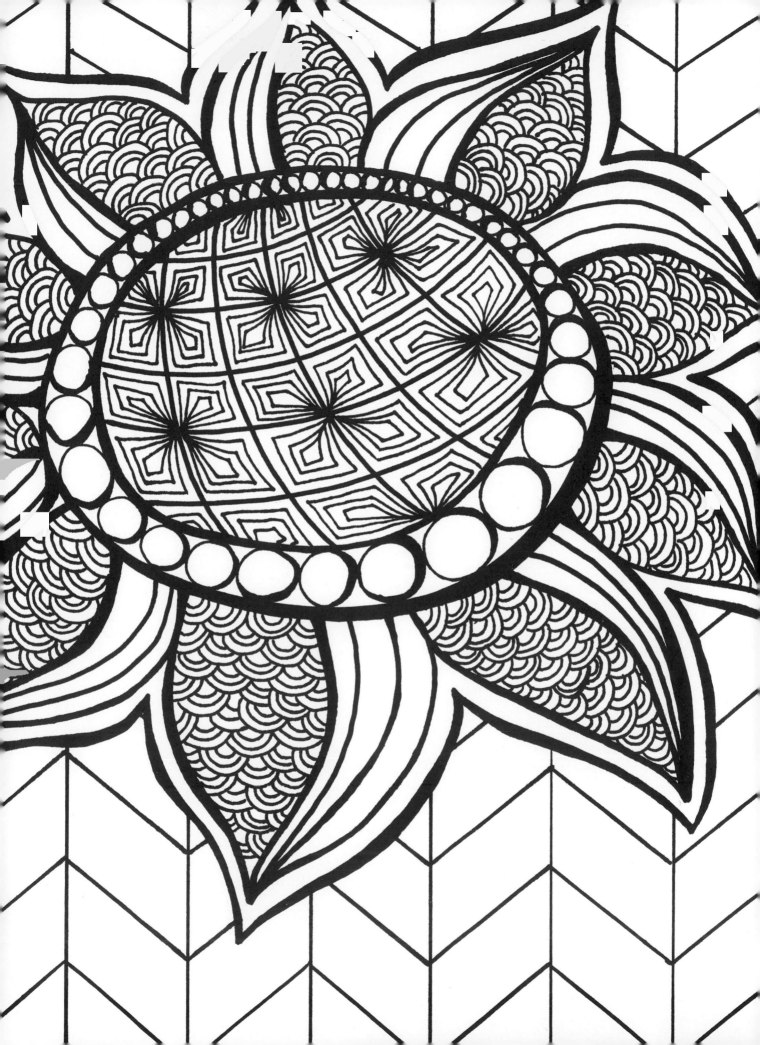

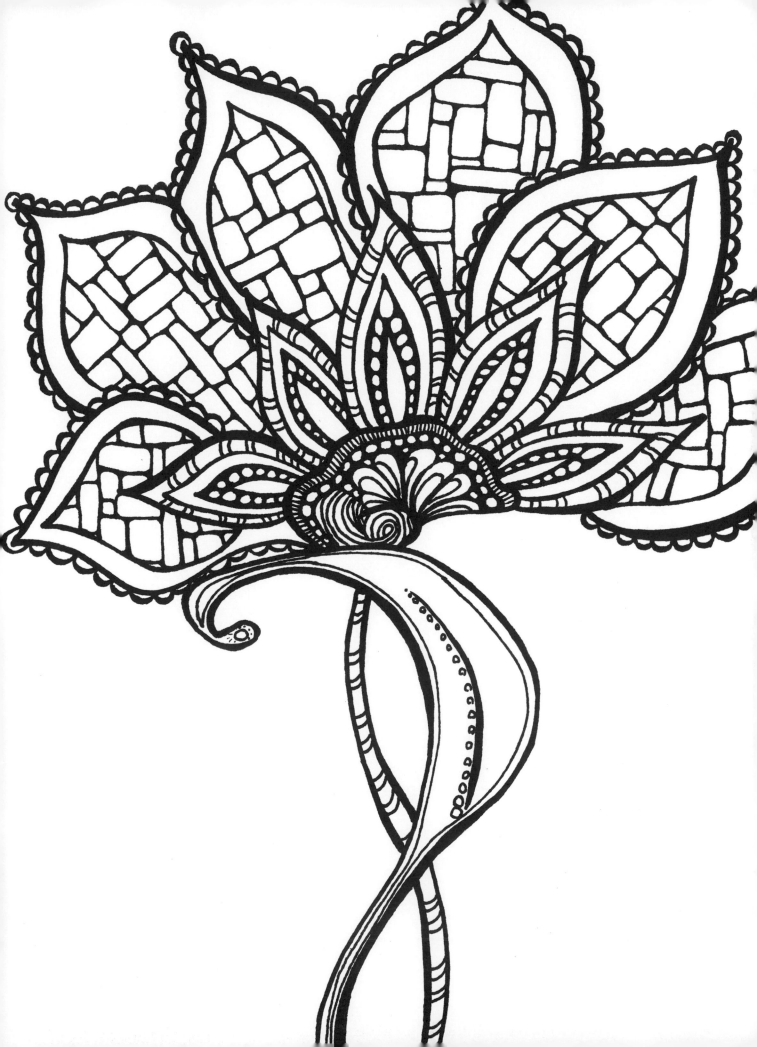

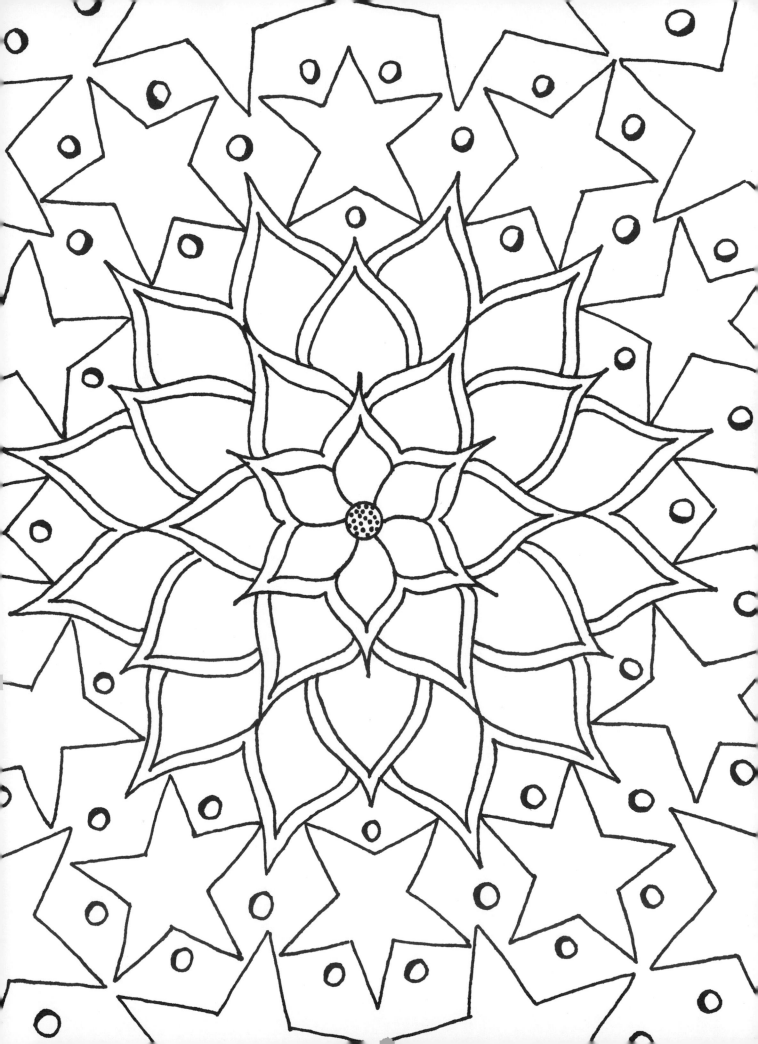

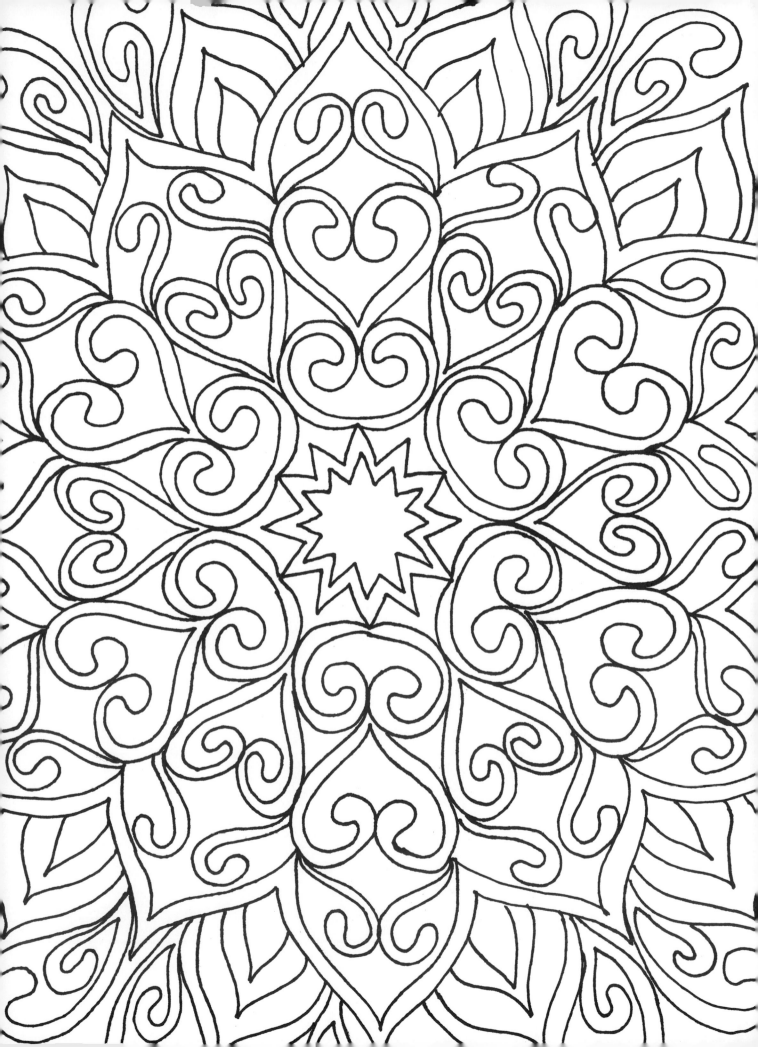

Download a printable PDF at
createmixedmedia.com/lovetocolor
for even more coloring fun!

fw

a content + ecommerce company

Other fine North Light Books are available from your favorite bookstore, art supply store or online supplier. Visit our website at fwmedia.com.

19 18 17 16 15 5 4 3 2 1

DISTRIBUTED IN CANADA BY FRASER DIRECT
100 Armstrong Avenue
Georgetown, ON, Canada L7G 5S4
Tel: (905) 877-4411

DISTRIBUTED IN THE U.K. AND EUROPE
BY F&W MEDIA INTERNATIONAL LTD
Brunel House, Forde Close, Newton Abbot, TQ12 4PU, UK
Tel: (+44) 1626 323200, Fax: (+44) 1626 323319
Email: enquiries@fwmedia.com

DISTRIBUTED IN AUSTRALIA BY CAPRICORN LINK
P.O. Box 704, S. Windsor NSW, 2756 Australia
Tel: (02) 4560-1600; Fax: (02) 4577 5288
Email: books@capricornlink.com.au

ISBN 13: 978-1-4403-4533-3

Edited by Beth Erikson
Cover designed by Jamie Olson
Interior designed by Brianna Schwarstein
Production coordinated by Jennifer Bass

about the Author

Tiffany Lovering started tangling as a fun and relaxing craft in between writing novels. As she learned the art of creating different patterns and techniques, tangling quickly became a passion she wanted to share with others.

In 2013 she created a YouTube channel dedicated to showing others her tangling techniques. She has since amassed more than 400 videos, 45,000 subscribers and 4 million views (and going strong!). In addition to YouTube, she has created a small Facebook community where fans can participate in a monthly tangle swap. She writes a blog discussing her inspiration and the processes of her more popular tangles.

Tiffany also has produced three North Light DVDs that cover tangle tips, techniques and patterns. She also teaches several online courses on tangling and mandalas throughout the year.

In addition to the art of tangling, Tiffany is passionate about reading and has a book review blog. She currently has four novels and one short story available on Amazon. She resides in Tennessee with her daughter, Allison.

Connect with Tiffany!

You Tube youtube.com/tiffanylovering

BLOG: tiffanytangles.blogspot.com

 facebook.com/TiffanyTangles

 twitter.com/tiffanylovering

Ideas. Instruction. Inspiration.

Receive FREE downloadable bonus materials when you sign up for our free newsletter at CreateMixedMedia.com.

These and other fine North Light products are available at your favorite art and craft retailer, bookstore or online supplier.

Find the latest issues of *Cloth Paper Scissors* on newsstands, or visit ClothPaperScissors.com.

CreateMixedMedia.com

- Connect with your favorite artists.

- Get the latest in mixed-media inspiration, instruction, tips, techniques and events.

- Be the first to get special deals on the products you need to improve your mixed-media endeavors.

 Follow CreateMixedMedia for the latest news, free demos and giveaways!

 Follow us !
@CMixedMedia

 Follow us !
CreateMixedMedia

These and other fine North Light mixed-media products are available at your local art & craft retailer, bookstore or online supplier. Visit our website: CreateMixedMedia.com.